Focus On Photoshop Lightroom

The *Focus On* Series

Photography is all about the end result—your photo. The *Focus On* series offers books with essential information so you can get the best photos without spending thousands of hours learning techniques or software skills. Each book focuses on a specific area of knowledge within photography, cutting through the often confusing waffle of photographic jargon to focus solely on showing you what you need to do to capture beautiful and dynamic shots every time you pick up your camera.

Titles in the *Focus On* series:

Focus On Photoshop Lightroom

Focus on the Fundamentals

Dave Stevenson and Nik Rawlinson

Focal Press
Taylor & Francis Group

NEW YORK AND LONDON

First published 2013
by Focal Press
70 Blanchard Rd Suite 402, Burlington, MA 01803

Simultaneously published in the UK
by Focal Press
2 Park Square, Milton Park, Abingdon, Oxon OX14 4RN

Focal Press is an imprint of the Taylor & Francis Group, an informa business

Library of Congress Cataloging in Publication Data
Stevenson, Dave.
 Focus on Photoshop lightroom / Dave Stevenson and Nik Rawlinson.
 pages cm. — (Focus on the fundamentals)
 Includes bibliographical references and index.
1. Adobe Photoshop lightroom. 2. Image processing—Digital techniques. 3. Photography—Digital techniques. I. Rawlinson, Nik. II. Title.
TR267.5.A355S74 2013
770—dc23
 2012039537

ISBN: 978-0-415-66323-6 (pbk)
ISBN: 978-0-203-55334-3 (ebk)

Typeset in Futura BT-Book
by TNQ Books and Journals, Chennai, India

Printed by 1010 Printing International Limited

Contents

Chapter 1: Welcome to Lightroom

WHEN ADOBE UNVEILED the first iteration of Lightroom in early 2006 it marked a radical departure from anything the company had previously produced. For starters, it was a Mac-only product, and it was given out free in unfinished "beta" condition. The idea, it seemed, was to strike a blow against Aperture, Apple's rival product for non-destructive, frame-wide image editing.

Lightroom has now reached version four. It works as well on PCs as it does on the Mac, and it's steadily built itself a commanding lead.

But what is it?

Key Points in this Chapter

Lightroom doesn't work like traditional editing tools. It's a pure developing and cataloguing application, while alternatives like Photoshop, Paint Shop Pro and Pixelmator should more accurately be described as compositing tools, where photos can just as easily be one asset that goes into the creation of a larger finished product. Here, photos take center stage, with many adjustments applied on a picture-wide basis, supplemented by a strong line-up of more localized tools, such as graduated filters and adjustment brushes. What it lacks, when compared directly to Photoshop, is layers support and compositing tools.

What is Photoshop Lightroom?

Lightroom is two things. First and foremost, it's a professional-grade image cataloguing tool. It's built from the ground up to handle large libraries containing many thousands of images, split into logical sub-groups and folders.

By attaching metadata to your images—effectively descriptive tags—you can further refine the catalogue. For professional photographers, whether established or just starting out, this is a boon, as it makes their images not only easy to find using the integrated search tool, but also more commercially viable, as we'll explain later.

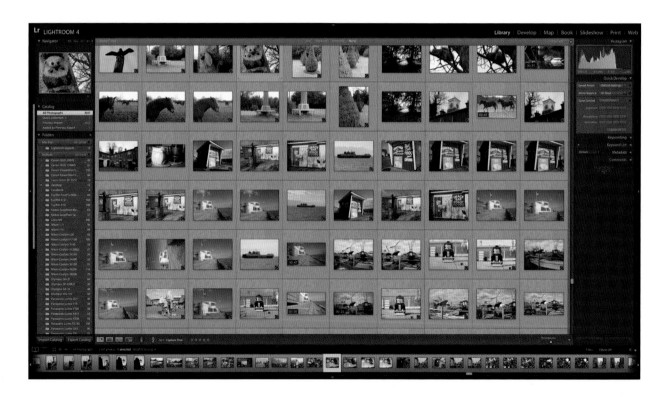

The Lightroom interface is split into discrete modules devoted to the various steps in the photo-editing workflow.

Lightroom is very aptly named. Consider it a tool for working with light, rather than pictures, in which you'll adjust the intensity, brightness or tone of the light that makes up your images, rather than directly editing their physical subject matter.

The second part of Lightroom is centered on improving—developing—your shots.

As its name suggests ("Lightroom" is a play on darkroom), the Lightroom workflow is heavily influenced by the centuries-old paper-and-chemicals process that first made photography possible.

In this respect, it's not geared up to perform a large number of localized edits like you would in Photoshop, but instead relies on you applying frame-wide adjustments to the whole of each image, along the lines of contrast and color correction, and tweaks to the strength of highlights and shadows. It's not designed to clone out pedestrians from street scenes, or ex-lovers from holiday shots, but can correct red eye, recover detail in selected areas, darken off burned-out patches and so on.

It's happy enough importing and developing regular JPEGs shot on consumer cameras. To really benefit from its advanced frame-wide adjustments, though, you should consider its abilities and which file format can best exploit them at the very start of your photography workflow.

If you have a Digital SLR (dSLR) or high-end compact shooter, like the Canon PowerShot G series, set it to record RAW files, and use these as your digital masters inside Lightroom.

RAW files contain the untouched data recorded by the camera sensor. It hasn't been converted into a JPEG, so won't have lost any detail or had an arbitrary series of color correcting and sharpening algorithms applied. Just about the only variable that's had an effect on the captured result is the length of the exposure, leaving you sufficient leeway to adjust the most fundamental settings in post production, with white balance, saturation, exposure and more all available for tweaking.

The Lightroom Workflow

Lightroom is tooled up to carefully manage your complete photography workflow (see chapter 9). By working your way through each of its modules in a logical manner you can quickly and easily identify your best shots, isolate them from the rest of your digital roll, and use them to create books, slideshows, websites, prints and movies.

Lightroom treats your imported RAW files as though they were negatives, and regardless of how

many adjustments you apply to them in the Develop module, it will always preserve them in their original state. This leaves you free to experiment without limits, safe in the knowledge that you can always wind back any adjustments you make to recover your original, and from there branch out in another direction to see what other results you might achieve.

This rolling back and starting over is greatly aided by the twin concepts of history and snapshots—features borrowed from Photoshop—that keep track of your adjustments and let you roll them back. So if, for example, you were happy with the progress of your edit until the point where you started to play with the tone curve you could step right back to that point while preserving any earlier adjustments.

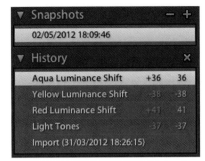

The Snapshots and History panes in the Lightroom sidebar make it easy to roll back your amendments to a previous good state.

The history panel is automatically populated as you work, tracking each of your adjustments in an ever-expanding list so that you can step back through them one—or more—at a time. The snapshots panel is where you'll create manual break points, each logically named, at the points where you were happy with what you'd achieved.

Creating a new snapshot when you're happy with the look of your edited photo lets you quickly return to it should you take things too far with subsequent edits.

The Lightroom Interface

It's worth taking some time to familiarize yourself with the Lightroom interface, which bears more than a passing resemblance to Adobe Photoshop, Photoshop Elements and Adobe Bridge, which ships as part of the company's Creative Suite. There's a simple reason for this: the Lightroom interface, which actually pre-dates the look and feel of the recently updated members of Creative Suite, was found to be so successful that it was rolled out to the other applications.

The knocked back interface is designed to be less distracting, so that your eyes are naturally drawn first and foremost to your photo. However, if you still find that there's too much visual clutter you can knock it back still further. Press L to cycle through the three view modes, with lights on the default, lights dimmed reducing the interface opacity to a set level, and lights out obscuring it altogether. By default the dimmed interface is reduced to 80 percent opacity, and the lights out mode surrounds your image with plain black, but if you find that neither of these suits your needs you can tweak them, reducing the opacity as far as 50 percent and changing the colored surround to dark grey, medium grey, light grey or white. You'll find these options on the Interface tab of Lightroom's preferences pane (on the Mac, click Lightroom | Preferences or use the shortcut command-comma; on Windows, click Edit | Preferences).

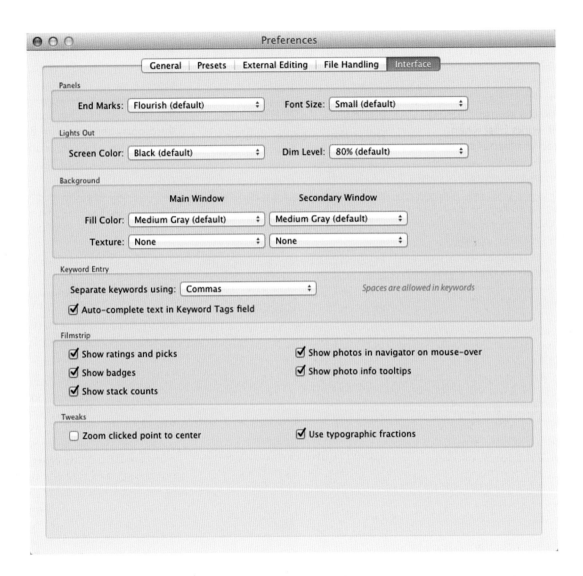

The comprehensive preferences pane lets you change the way Lightroom both works and, in this case, looks.

Lightroom is a single-window application. That is, all of your controls, thumbnails and active photos are wrapped up in a single interface rather than being split up across several floating panels. It works best when maximized to fill your screen. Tap F to maximize it, and once again to remove the menu bar so that all of your available pixels are given over to the image preview pane and controls. Tapping F for a third time returns you to your original window configuration.

You can individually collapse the surrounding panels by clicking the arrows above, below, and to the left and right of the interface. Clicking them again when the panels are collapsed brings them back, but if you only need to dip in to make a quick adjustment, simply hover over the appropriate arrow and its panel will temporarily reappear, allowing you to make your changes. As soon as you move your pointer away from the panel it disappears again.

If you have a secondary display, then Lightroom can spread itself across both monitors, giving over one to photo management tasks while devoting the other to editing.

Lightroom Modules

The various modules through which you'll work when organizing and editing photos in Lightroom are presented in the upper-right corner. Everything starts with the Library module, which is where you'll import your photos and select the ones you want to edit. Although this is largely the organizational part of the application—the bulk of your edits will be performed in the Develop module—you can still apply rudimentary tweaks using the Quick Develop panel to the right of the main library window, and expand the keyword and metadata panels using the disclosure triangles to help refine your catalogue. The more relevant keywords you can add to any image, the more likely it is that you'll be able to find it in the future by performing edits that cut across every folder in your library.

The Develop module builds on the Quick Develop pane by opening up Lightroom's full range of editing options, while Book, Slideshow, Print and Web are the modules through which you'll output your work. Some of the features on offer here require third party services. The Book module, for example, can send your work directly to Blurb, a commercial printer, which will print it for a fee (although if you prefer to print it yourself you can output the pages as a widely-accepted PDF). The Slideshow module can export your work as a movie file or PDF, while the Web module can upload your creations directly to an FTP server, either for public consumption or previewing by clients.

The Develop module includes a number of pre-set adjustments designed to get you up and running on day one, including automatic tone enhancement, color effects such as cross processing and artificial ageing, black and white settings that mimic traditional colored filters to accentuate particular tones, and more creative effects, such as vignette, grain and rounded corners.

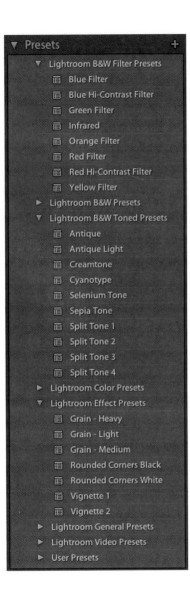

The Develop module's Presets pane contains a selection of the most commonly-used adjustments.

While these are great starting points, to really get the most out of the application, and to give your photos a personal touch that will really make them your own, you should get to grips with the manual editing tools that sit to the right of the Develop module interface. These give you fine-grained control over individual aspects of your photo to a far greater degree than a traditional image editor like Photoshop, with direct access to split toning effects for highlights and shadow, noise reduction and camera calibration.

The effects are grouped into logical families, which can be switched on and off at will to really push your creative output to the limit.

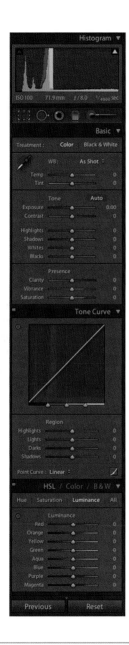

Using the full range of adjustments gives you greater control over the look of your finished image than the quick presets can.

In the chapters that follow we'll walk you through each of these modules and show you how to get the most out of your photos. We'll start with the very first step—importing your photos. So, dig out your memory card, fire up Lightroom, and let us begin.

While the Lightroom interface might look daunting the first time you encounter it, you simply need to remember to work from left to right on the modules. Import and catalogue your images through the Library, edit them in Develop and create products in the Book, Slideshow, Print and Web elements.

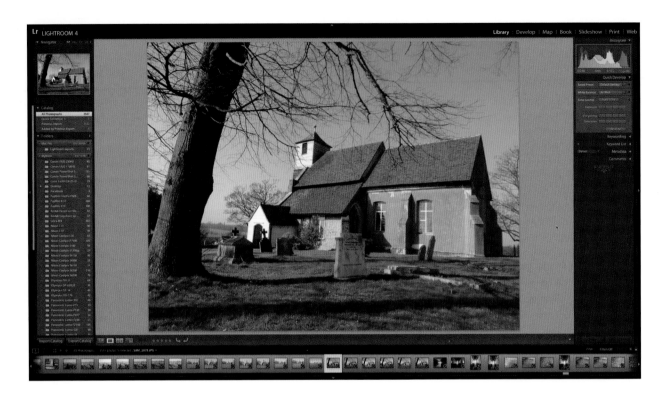

Lightroom 4 interface overview shot with Develop module active.

Lightroom Versions

Unlike Photoshop, which comes as Standard or Extended, depending on your needs, or Windows, for which there's usually three of four flavours of each edition, Adobe only ships one version of Lightroom at a time.

At the point of writing, the most recent release is Lightroom 4.1. Therefore, in the chapters that follow, wherever we cover a feature specific to Lightroom 4.1 or later that wasn't present in previous releases we will make it clear which edition is required. On the whole, though, the principles outlined in this book, and the work throughs used to explain them, will apply equally to each release.

Chapter 2: Organizing Your Library

As a new Lightroom user you're in an enviable position. With an empty library to populate you can start from scratch, and make sure that every photo you import is properly and logically filed. The result will be a collection that is easier to navigate and thus more useful over the long term.

Effective organization isn't simply a matter of splitting your photos into named folders. While this plays a part, you should also be adding tags to describe them and metadata that both marks them out as your own and which can be used by photo agencies to catalogue your work and ensure it's properly captioned and credited when used by third parties.

Get into the habit of treating the digital transfer of photos from card to computer as just one step in the import process, and set aside a few minutes at the start of every editing session to keep them in order. Take care of your filing and Lightroom will help you get more out of your pictures than you ever would if you simply dropped them into a folder on your hard drive.

Key Points in this Chapter

In this chapter we'll walk you through the process of importing your first batch of photos and adding the necessary metadata that will make them more useful, however you intend to employ them. With carefully selected keywords applied to each one you'll be able to find exactly the shot you're after when creating books, websites and slideshows. Professional photographers can use the industry-standard frameworks for IPTC metadata to prepare their work for sale through photo agencies.

Importing Your Images

However you choose to shoot your images, whichever format you save them as, and whatever media card you use, the import process follows a logical, step-by-step routine. Get started by inserting your memory card and switching to the Library module.

This is the part of Lightroom through which you'll perform all of the management tasks that we'll cover in this chapter. In the next chapter we'll show you how to further catalogue your assets before going on to edit your images in the Develop module, in Chapter 4. Tempting though it may be to move on right away to the editing process, don't neglect the key management tasks in this and the next chapter if you're serious about building a useful working library.

The Library module presents your existing image sources—cards, hard drives, remote servers, folders and so on—in the left-hand panel, at the bottom of which you'll find an Import ... button. Click this and select the source of your images—most likely your memory card—at the top of the import dialogue window.

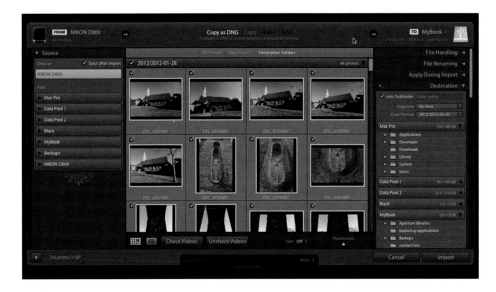

The import dialogue is a place to which you'll return every time you want to add new images to your library. The bar at the top of the screen summarizes the current import workflow.

Take a moment to familiarize yourself with the import dialogue, as you'll return to it every time you add photos to the Lightroom catalogue. As with the main application interface, you work through it in a logical manner from left to right, and top to bottom. (If your import dialogue doesn't look like ours, but is instead a narrow bar across the center of the display, click the down-pointing arrow in the lower left-hand corner to expand the full options.)

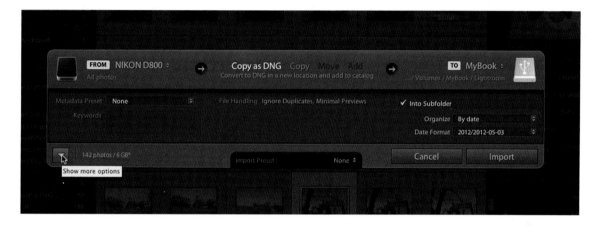

Your import dialogue may be a collapsed bar running across the center of the screen. To reveal the full set of options, click the down-pointing arrow on the bottom row.

At the top of the screen you'll see a summary of your present workflow, which will be set to however you left it the last time you imported any images. If you have not imported any images before, it will be set to copy them to your Library in their existing format, although you can change this to copy them as Digital Negatives (DNG).

The images' destination is shown on the right. Clicking the double-headed arrow beside the drive icon here lets you choose from a selection of commonly-used and recently-used folders.

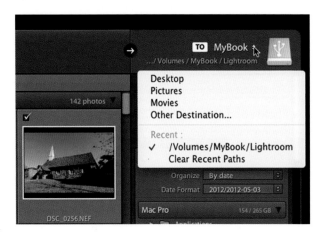

You'll find common and recently-used destination folders on the right-hand end of the summary bar. Click one if you frequently use a small subset of folders for storing your imported images.

In many instances you can import your images without changing any of these default settings but, as we said at the outset, the more effort you put into managing your images at the point of import, the more useful you'll find your library in the future. At this point, then, you should step down to the main body of the dialogue.

LIGHTROOM IMAGE FORMATS

Lightroom uses the Adobe Camera RAW processor to import a wide range of cameras' native data. The range is constantly expanding, so visit adobe.com/go/learn_ps_cameraraw for the current list. It's worth checking that any camera you plan on buying in the future is supported by Lightroom if you want to get the most out of your shots.

Aside from these RAW formats it can also work with TIFF, JPEG and native Photoshop format (PSD) files and Digital Negative (DNG).

DNG is an open, TIFF-based image format developed by Adobe and a neutral go-between for importing, managing and archiving RAW images. Recognizing that over time the various RAW formats used by different camera manufacturers will slowly fall out of use, the company wanted to establish a manufacturer-agnostic format that could be put forward for adoption as an industry standard. Lightroom can convert your RAW images to DNG format at the point of import.

Tweaking the Import Workflow

If Lightroom detects a connected camera or memory card it will assume that this is the source from which you want to import your images. If that's incorrect, use the left sidebar to navigate to the folder containing the photos you want to add to your library.

It's up to you how many images you import. The main body of the import dialogue—the larger central window—shows you which have been selected, with three options above them—All Photos, New Photos and Destination folders—giving you control over the selection displayed below.

All Photos shows all of the images in the source folder or stored on the memory card. New Photos trims the display so that it only shows those images that Lightroom doesn't think it's imported in the past, and Destination folders organizes the images in such as way as to represent how they'll be organized once they arrive in your Lightroom library.

In this example, the Lightroom import process is set up to convert your images to DNG format on import, while the main thumbnail window can be set to display different views of your source files.

All Photos

This is the most versatile view, and also the one that leaves you to do the most work yourself. It lumps all of your photos into a single collection in the central portion of the import dialogue and lets you check off the ones you don't want to import. Use the Check All and Uncheck All buttons to make changes en masse, or click individual check boxes to work on them one at a time. Selecting a group of images and then clicking the check box for any one of them either selects or deselects the whole group, depending on the original state of the box you checked.

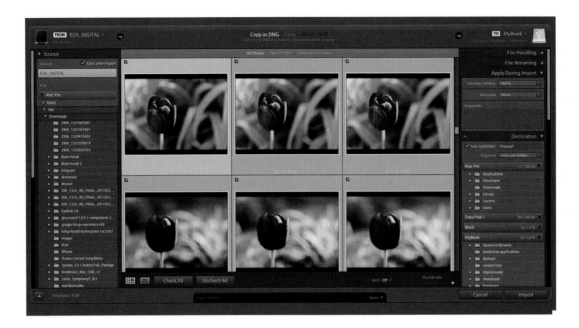

Selecting a range of images and then clicking or clearing a check box within it sets all of the other selected images to the same checked or unchecked state.

New Photos

With New photos selected, Lightroom uses the metadata attached to each image to compare it to those in your existing catalogue. If it finds a match in the catalogue, it doesn't display the image in the import dialogue. This lets you quickly mop up stray images that may have not been imported in the past, and delete duplicate folders of images you've already added to your collection to free up disk space.

Destination Folders

This view organizes your potential imports in a way that represents their final organization within the Lightroom library. By default it will show them broken down into groups for the days on which they were shot, allowing you to quickly and easily split up a folder full of travel photos into individual days that will likely also mark the divisions between different activities or locations. You can change the divisions shown here using the Destination tab in the right sidebar, as we'll explain below.

File Handling

Once you've selected the images you want to import, you need to tell Lightroom how they should be handled. This is your chance to automate some of the work you would otherwise have to do later on by setting up a sequence of events that you can save for use on future imports. By doing this you'll ensure that all of your images are handled in the same way, that they will conform to the same set of rules, be filed in a logical manner, and will be easy to locate when you want to edit

them or use them to produce books, websites and slideshows.

Start at the top of the right-hand pane and work your way through the options, starting with File Handling. Click the disclosure triangle to expand its options.

Backing up During Import

By default, Lightroom imports a record of your images into its catalogue and leaves everything else as it stands. However, it

makes sense to take this opportunity to immediately create a backup set at the same time, preferably on an external drive or remote server.

The "Make a second copy to:" option first appeared in Lightroom 3 and persists in Lightroom 4. Check the box beside it to add this action to your import workflow and then select the destination folder by clicking the line below and navigating to it through the OS X Finder or Windows Explorer.

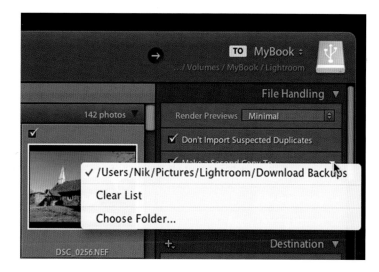

It makes sense to take care of backing up your images as part of the import process to save you having to think about it later on.

Lightroom will already have set up a Download Backups folder inside your Lightroom directory. However, good backup practice would dictate that you should avoid using this unless you have no other choice, as losing your computer to fire, flood or theft would mean that you have lost not only your catalogue but also the images themselves. At the very least use an attached external hard drive or NAS (Network Attached Storage drive on your local network).

Beside this you'll find options to skip duplicates and render previews in four different ways. Because RAW files are very resource hungry, working with

them directly would cause Lightroom to run very slowly. Not only would this be frustrating; it would also seriously impact your daily productivity. Lightroom therefore creates JPEG previews of each image at the point of import, which it uses to display your assets in the Library module. It refers back to the RAW files when rendering your adjustments at the point when it outputs your work.

Minimal previews are drawn from the data written by your camera. They are low resolution samples used to build the film strip at the bottom of the Lightroom interface and in the Library grid view. The

Embedded and Sidecar option, although larger, again draws on the previews written by the camera, but Standard and 1:1 are generated by Lightroom itself by running the RAW file through its Camera RAW processor to build a bespoke JPEG file. Of these, previews rendered at 1:1 are the largest, with the JPEG file exactly the same resolution as the original RAW file. If you don't create 1:1 previews now, be sure to render them once you've completed the import process—perhaps as you leave work for the day, so you can set it to work while you're not about. You can do this clicking Library | Previews | Render 1:1 previews.

Image previews are used to speed up the process of working with images in Lightroom. Although it takes a bit of time to create them at the point of import, they will save you a lot of time in the long run.

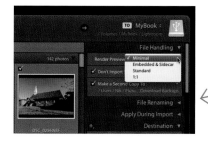

If you're pressed for time you can set Lightroom to only create small previews during the import process.

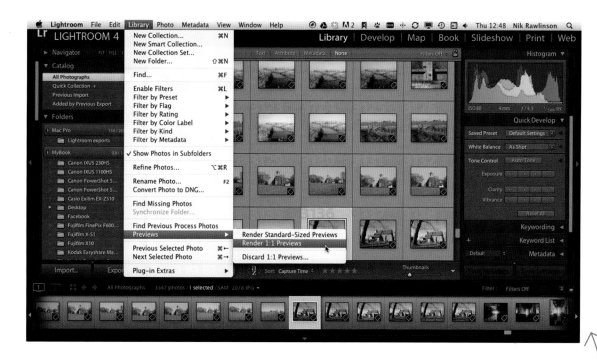

If you don't have time to generate 1:1 previews at the point of import, put aside some time to create them manually through the option on the Library menu.

Before going any further, you should define the size of your standard previews to match your monitor resolution so that you can achieve the perfect balance of high-quality full-screen editing while conserving disk space. On the Mac click Lightroom | Catalog settings; on Windows click Edit | Catalog settings. Click the File Handling tab and use the Standard Preview Size drop-down menu to select the resolution that most closely matches the horizontal resolution of your monitor, then OK out of the dialogue.

Once you've taken care of that, continue working your way down the right sidebar.

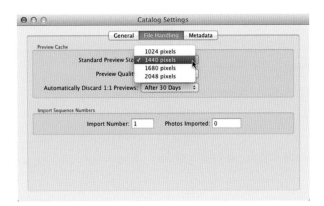

There's no point generating preview files larger than your screen can display. Set up Lightroom's Standard Preview Size to match the horizontal resolution of your monitor.

File Renaming

We're going to organize our images into a logical folder structure later in the import workflow, but it pays dividends to also consider how you'd like the individual photos themselves to be named. This is particularly important if you're using Lightroom as part of a team and have an established filing system with which you need to conform, or if you're processing images for a client that requires the use of particular filenames for their own internal purposes. Fixing the filenames at the point of import saves you from manually tweaking them at the end of your workflow.

If you need to adjust your images' filenames, expand the File Renaming panel, check the box beside Rename Files and choose one of the template options. Several of these, such as Shoot Name and Custom Name give you the option to add your own text to the filename with Lightroom taking care of appending sequential numbers to each one to differentiate them.

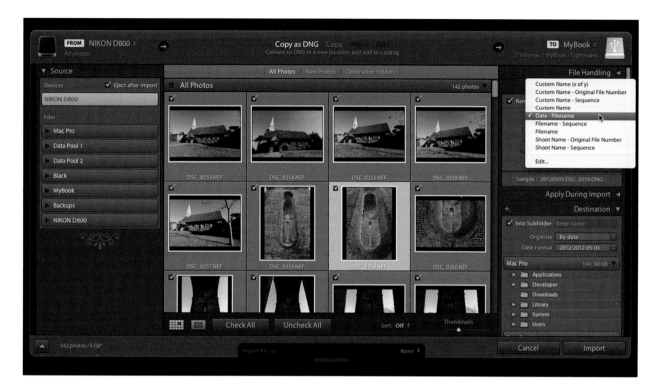

Lightroom has a series of built-in options for renaming files at the point of import.

The most versatile option in this menu, though, is Edit, which lets you build your own filename processor by selecting various metadata and dragging them into a sequence.

The range of data points available here is extremely fine-grained, and includes such shooting variables as brightness value, sensitivity, exposure bias and even the serial number of

the camera. When used with care they make it easy to filter the output results of your editing activities directly within your computer file system.

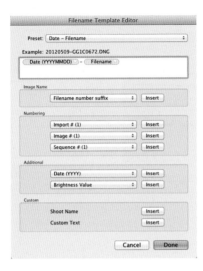

If you can't find a renaming preset that meets your needs, the Filename Template Editor lets you build up a complex name derived from each image's underlying metadata.

You'll notice that Lightroom displays a sample of the resulting filename for each image as you click between them in the grid view that updates on the fly.

Applying Adjustments and Metadata while Importing

Although the Import dialogue is focused entirely on adding images to your library, it can simultaneously apply pre-set adjustments by selecting them from the Apply During Import panel.

When you're using Lightroom for the first time this will only contain links to the default Lightroom presets, which are organized into logical groups covering black-and-white processing, color presets and video tweaks. When you have been using Lightroom for some time and you've saved your own adjustment combinations or imported third-party add-ons, they'll appear alongside these in a User presets folder within the adjustments menu.

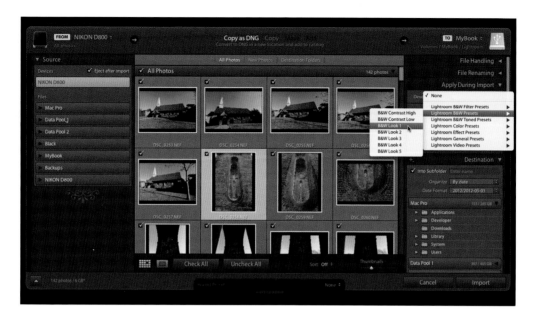

Although you'll do most of your editing work in the Develop module, you can apply pre-set adjustments at the point of import.

In most instances it's better to apply adjustments on an image-by-image basis in the Develop module, but if you know that your camera tends, for example, to oversaturate blues under certain conditions then this is a quick way to correct that before you start work on your images in the main body of Lightroom.

This is also the place where you should apply metadata to your images to help Lightroom catalogue them. If you only want to apply a small number of keywords, then you can add these in the Keywords box, but the more efficient way to add standard metadata is to create a

preset that you can re-use on future imports.

There won't be any to choose from the first time you use the presets feature, so click the drop-down selector beside Metadata and select New ...

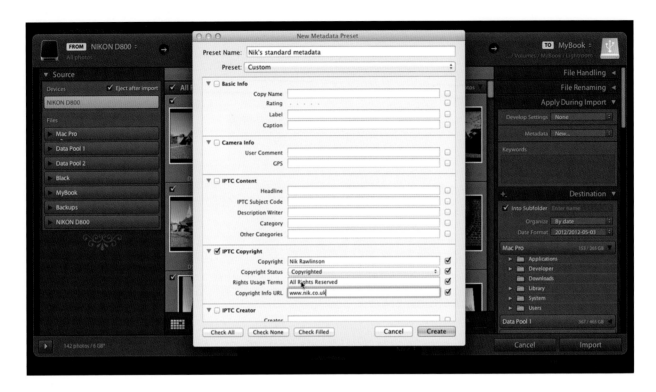

Creating a metadata preset lets you quickly apply set data to multiple images without typing out the entries by hand for each image or batch.

This calls up a comprehensive form containing every conceivable data type, but there's no need to fill out every box. Indeed, as you're defining your first preset doing so would actually be unwise. Why? Because you should focus on supplying only those details that can be applied accurately to all of your images.

For example, copyright name and URL for further copyright information, creator name and address could all be applied to every image you create, but date could not. Scroll through the form and add as much generic information as you can, then

save your preset by clicking Create. You'll see that it's now selected in the Metadata drop-down in the Apply During Import panel. You can add further project-specific metadata in the Library module once you've completed the import process.

IPTC Metadata

You'll notice as you work your way through the preset creation dialogue that it makes frequent references to IPTC. This stands for the International Press Telecommunications Council, which oversees a standard set of metadata variables used by picture agencies and publishers to trade in and organize images. Applying the relevant IPTC metadata at this point puts you one step ahead at the end of your image processing workflow (see Chapter 9).

Metadata is a series of tags that describe certain things about your images, such as the date on which they were shot, the white balance selected on your camera, the camera model and so on. All of it can be useful when it comes to filing and marketing your work.

Importing Your Photos

Finally, with your images fully described, a range of pre-set adjustments applied, the photos you want to import selected and your preview quality settled upon, Lightroom is ready to import them. Don't worry if it's taken you several minutes to get to this stage the first time around. The more often you import photos the shorter the process will become—particularly once you've set up and saved presets for your own personalized metadata and preferred adjustments.

By saving your current import settings in a preset of their own you can cut out all but the final step for future imports. To do this, click Save Current Settings as New Preset at the bottom of the interface and give the settings a descriptive name that will help identify them in the future. You can save several import presets in this way, so you can treat different subject matter in a range of different ways.

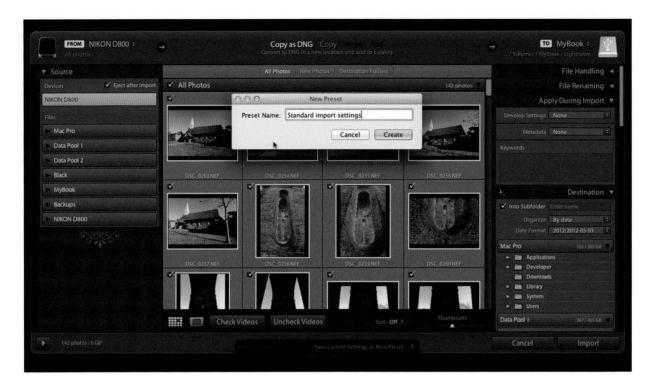

Once you have set up your own personalized import workflow, saving it as a preset lets you apply it again in the future.

Adding Images to Your Library

Expand the Destination panel by clicking its disclosure triangle and choose where you'd like to store your images. Start by clicking on the drive—and optionally folder—that you want to use, and then check the box beside Into Sub-folder, and give the new sub-folder a name. Lightroom can further sub-divide the imported images by date if you choose that from the Organize drop-down, or drop them all into the same folder.

Once you're happy—and having looked back through your settings in the other import dialogue bricks (panels)—click Import to complete the process. Lightroom gets to work importing your images and converting them to DNG format if appropriate, with a progress bar in the upper left corner of the interface showing you how close it is to completion.

The progress bar at the top of the interface shows you how much longer it will take Lightroom to add images to your library and, if you've selected the DNG option, convert them to digital negative format.

Next Steps

You've now completed the first step in the digital processing workflow: cataloguing your images in the Lightroom library. However tempting it might be to switch to the Develop module and start tweaking your shots, though, you should spend some more time in the Library module finishing off the cataloguing process to make your images easier to find, geo-tagging them so that they can be plotted on the integrated Lightroom map and setting up automatic collections that will perform a lot of the sorting work on your behalf. We'll show you how to do all of this in Chapter 3.

Chapter 3: Managing Your Shots

Now that you've imported your shots and added them to the Lightroom catalogue, you could go on to start editing them right away. There's nothing wrong with that now and then if you're pressed for time, but if you're serious about using Lightroom to its full potential you should first spend some time properly cataloguing your assets.

You might think you've already done that at the point of import when you selected a folder in which to store them and keep them separate from your other images, but that's only one small task in the process of building a comprehensive, well-organized catalogue.

By spending a few extra minutes immediately after completing each import adding further metadata, plotting your images on a map and building collections that will automatically sort and group your shots without any further intervention from yourself, you can save an enormous amount of time later on.

You'll immediately know where to find the assets you want at any time without spending a lot of time searching through your collection. Think of it as setting out a series of pointers for your future use. If it all sounds like too much work, consider this: you might know exactly where to find the images you've imported right now, but when you've done the same with another dozen or so memory cards over the next two or three months, will that still be the case? If you've completed the tasks in this chapter, the answer will be "yes." If you haven't, your chances will be greatly reduced.

> ### Key Points in this Chapter
>
> In this chapter we'll show you how to organize your images into folders, plot them on a map and build smart collections that will automatically organize your assets according to variables attached to each one. The aim is to build a comprehensive library that will in part run itself by gathering appropriate images together and make each of your assets easier to find. With this achieved you'll spend less time searching and sorting, and more time creating great-looking products with your photos.

Stacking Your Photos

One of the first tasks of the professional photographer is to sort their images so that they can quickly and easily identify their best work. Even if you're using Lightroom in a personal capacity you'll want to isolate your very best shots so that you can compile them into a slideshow or book, print them or publish them on the Web.

Often you'll take several shots of the same subject or scene from different angles and with different camera settings. Your job will be to look through each of them and exclude the substandard results.

The best way to do this is to group those mini shoots into stacks, with the best image used as the single frame that represents each of the shots in the stack. A side benefit of working this way is that it helps to hide the sub-optimal images in the Library module overview so that only your best work is on view at any time.

You can stack images in two ways—either manually or automatically based on the interval between each shot.

To stack your images manually, select the sub-group of images that you want to gather together, right click one of them or open the Photo menu and select Stacking | Group into Stack. Mac users can use the shortcut command-G; Windows users can do the same using ctrl-G.

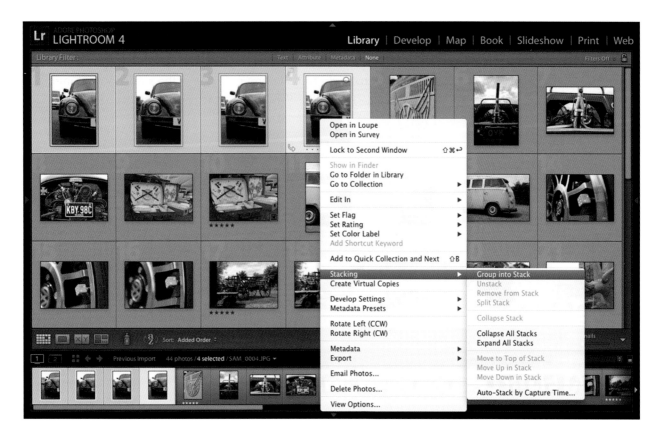

Stacking your images lets you group similar photos or shots taken in quick succession so that only the best is shown. This will help you navigate your library more effectively.

This arranges your images into a digital pile, with a chip in the upper-left corner showing how many images the stack contains. Clicking the chip expands the stack to reveal its contents. If you later need to unstack the images, reverse the stacking action through the Photo or right-click menus, or use the shortcut command-shift-G on the Mac and ctrl-shift-G on Windows.

To stack your images automatically, select the collection of images you want to work with—ideally a folder containing a recent import—and select Photos | Stacking | Auto Stack by Capture Time …

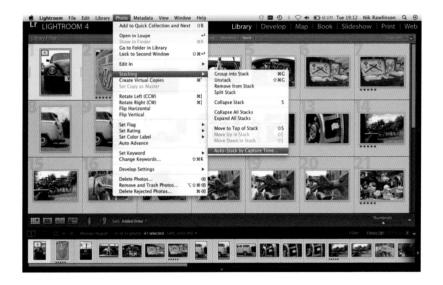

Get Lightroom to do the hard work for you by giving it the job of automatically stacking your newly-added images on the basis of when they were shot.

Lightroom assumes that images taken in quick succession are likely to be of a similar subject. You just need to tell it how large a window to use when grouping them.

Selecting Auto Stack by Capture Time … calls up a simple dialogue containing a single slider used to specify the size of the timeframe into which each shot should be gathered. Dragging to the right allows more leeway, so the pauses between each shot can be longer. Dragging to the left shortens this metric. As a result, dragging to the right gathers more images into each stack and creates fewer stacks; dragging to the left does the opposite. Lightroom previews the start point of each stack in the Library module overview by adding a chip to the corner of each one.

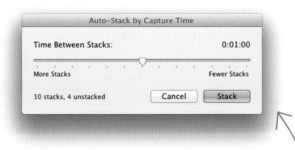

Dragging the slider groups more of your images together as it lengthens each virtual shooting session; pulling it back to the left creates smaller stacks, which may be less useful as it will not condense your library to the same degree.

You can add images to an existing stack by dragging one or more selected shots onto the stack in the Library module.

Using Stacks to Grade Images

Now that you have grouped your images so that similar shots sit alongside each other you can easily pick out the best shot from each group.

You can use any of the regular flag and rating markers here: clicking the spots beneath each image in the Library module overview or using buttons 1 to 5 on the keyboard to give them a rating (zero removes the rating), or clicking the flag icon in the upper-left corner of the image container box within the Library to flag it for future attention.

However, having stacked your images it is often easier to simply look at your shots in their sub-groups and drag your best shot to the top of the stack so that when the stack is collapsed it's the only one on view.

You can save yourself some time by simply dragging your best shot to the top of the stack instead of working through the usual rating process. When your stacks are collapsed you will then only ever see your best work in the Library module overview.

Do this either by dragging it from its current position within the stack onto the top of the first frame in the group, or use the keyboard shortcut shift-S. You can move your other images up and down the stack one space at a time by holding shift and pressing '[' to demote an image within the stack and ']' to promote it.

Keep in mind the fact that when you stack your images and collapse the stack, changes that you apply to your images, such as flagging, labeling or adding keywords, will only apply to the top-most image. The same is true of rendering previews. If you want to add data to each image in a stack, be sure to expand the stack first and select each image you want to affect.

FIVE WAYS TO RATE YOUR IMAGES

Rating your images is one of the most effective ways to isolate your best work, as you can use your ratings as one of the metadata variables matched by a Smart Collection or the filter bar that sits immediately above the film strip. Fortunately Lightroom makes it easy to apply ratings, courtesy of a series of keyboard shortcuts and clickable points on the user interface. Here's how:

1. Click between one and five spots below each image in the Library module overview.

2. Switch to the Default view in the Metadata panel in the right sidebar and click the spots beside Rating.

3. Select an image and use the numbers 1 to 5 on your keyboard.

4. Use the stars below a single image view (loupe view) in the Library module.

5. Use left square bracket to increase a rating and right square bracket to decrease it on any selected image in the Library or Develop modules.

Filtering Your Images

Once you have started to rate and classify your images you can use those ratings as a basis on which to filter them so that you can identify your best work.

Text Search

The Library Filter bar sits above the thumbnails in the Library module. Selecting Text lets you use freeform plain-language terms to search any field in the metadata database. If you've been careful to add relevant keywords to your images you'll reap your rewards at this point as you'll be able to use them as data points in your search.

You can further tailor your text searches by using the drop-down menus to the left of the search box to restrict your searching to only specific fields and,

optionally, choose whether the field should include or preclude all or some of the specified terms, and whether they appear at the start or end of the result string.

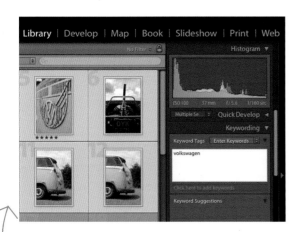

Adding keywords to your images when you import them will let you use those natural-language terms in future searches.

Lightroom's natural language search tool lets you specify where in a string of results your chosen words should appear, and even specify that they shouldn't be included at all if you want to preclude a particular set of results.

Attribute Search

Attribute Search gives you one-click access to common attributes, such as a photo's rating, whether or not it's been flagged, and which color you've used to mark it up. It also lets you isolate master copies, virtual copies and videos. You can select several such attributes by clicking them in sequence, so if you wanted both videos and master copies rated three or above you would click the master copies and videos icons, the three-star rating and the equal to or greater than symbol that appears at the very start of the rating section.

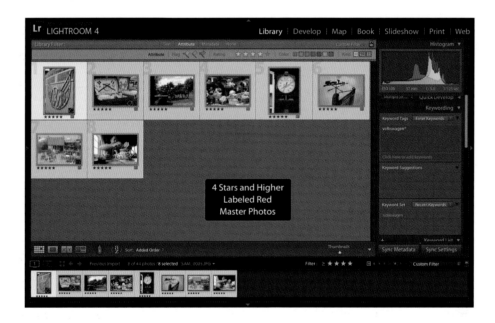

Using the Attribute search bar lets you specify a range of applied ratings, colors and flags, and also what status your images have, such as whether or not they are masters.

Metadata Search

Metadata Search splits the various metadata categories into columns. It's used in conjunction with the Filter drop-down that appears on the line immediately above.

By selecting an entry from each column you can gradually define an ever finer selection of results from the images in your catalogue. If you don't want to specify an attribute in any particular category, you can simply leave All selected at the top of the list. So, if you've used a variety of cameras during the time you've been building up your catalogue, for example, you could leave the All entry selected in this column to take that attribute out of the search query.

We will use this method of searching again later in this chapter when we start working with map data.

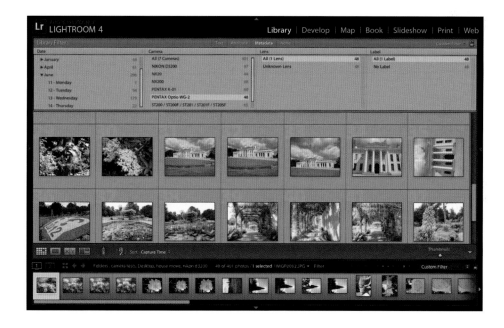

The Metadata search makes it easy to search for images for which you can't identify the specific search terms or ratings that would turn up a relevant result. Clicking in each column whittles down the matches until only those relevant to your query remain.

If you build a query in this way that you know you'll need to use again in the future, it makes sense to save it as a metadata filter preset. Click the preset selection drop-down menu on the Library Filter row and select Save Current Settings as New Preset … When you've given it a name and saved it, this will appear in the filter presets drop-down menu for future use.

Saving the attributes of a Metadata search lets you quickly repeat the search operation in the future without stepping through each of the variable columns again.

Metadata Search Quick Tip

Select metadata from multiple columns and only those images that contain all of the selected attributes will be returned. Select metadata from multiple entries in a single column, though, and images that satisfy any one or more of the conditions will be returned.

TEXT- AND ATTRIBUTE-BASED FILTERING

The Filter Bar is also the location in which text-based searches and attribute-based filtering is carried out. Placing a + at the beginning of a word is the same as "starts with," placing one at the end of a word is the same as "ends with," and placing a ! at the beginning of a word is the same as "doesn't contain." It's also worth noting that the Attribute bar contains White and Gray label chips for Custom Label and No Label respectively. Multiple filters are activated by shift clicking the respective filter name so, for example, click Text then shift-click Attribute followed by shift-clicking Metadata.

Flagging Images

As you work through your latest batch of imported images, you need to work out which ones are worth working on and which should be rejected right away. Lightroom lets you do this using a series of flags.

By default, all images are "unflagged" when you first import them. Right-clicking them, either one at a time or as a selected range, lets you flag them or immediately reject them outright, or you can use keyboard shortcuts, in which P will set a flat to On, U will set it to Off, and X will set it to reject. Notice, as you do, that the flag icon above the photo in the library view changes color to indicate the image status.

You can use a photo's flag status as one of the attributes on which to perform a metadata search. This means you could, for example, quickly review rejected images to make sure no usable shots have slipped through, work on unflagged images to which you can later add a flag, or find flagged images that you want to process.

The selected images in this Library view have been flagged. An image's flag status is one of the attributes on which you can search. Flagging images that need further work or review is therefore an efficient way to make sure you'll always be able to find them at the start of your next editing session.

Comparing and Surveying Images to Identify Your Best Shot

Surveying and comparing images is another way to identify the best shot from a collection. Compare lets you examine two shots side by side to determine which is better; Survey lets you do the same with a larger number of shots. You'll find the buttons to switch to either mode on the toolbar immediately below the Library module's thumbnail grid, or use the keyboard shortcuts C and N respectively to switch to them directly.

Comparing Images

Select the two images you'd like to compare and click the tool-bar's XY button or press C on your keyboard. Lightroom displays the two images side by side, with the selected image—the one that you think is best—on the left, and the one to which you want to compare it on the right. If they are the wrong way around, and your best image is to the right, click the Swap button further along the toolbar.

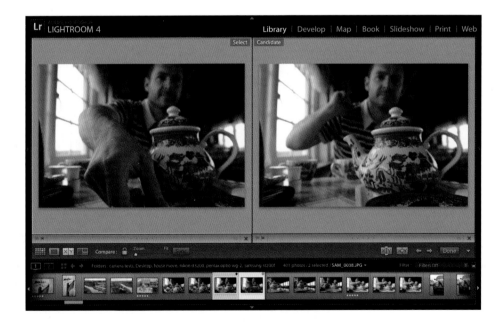

The Library's Compare view arranges a sequence of images side by side, two at a time, so that you can work through your collection and pick out the best from a selection of shots.

Your best shot—the one to which you want to compare your others—must appear in the left hand Select window. If your shots are in the wrong positions, use the Swap button to switch them around. Here, it's the one on the extreme left.

You can rate either image by selecting it and then using any of the five rating methods outlined above (p.36).

When you are sure that the image to the left is the best of the two, click the right arrow on the toolbar to move on to the next image in the catalogue. This swaps the Candidate image for the next image in the film strip and lets you repeat the above rating operation on the new shot.

If you decide that a Candidate shot is better than the current Select image, you need to discard the Select image and promote the Candidate shot into its position. This way you can continue the rating process by comparing all future shots with your newly discovered best work. Do this by clicking the Make Select button on the right of the toolbar. Your current Select image will be discarded, the Candidate shot will take its place, and the next image in the film strip will become the new Candidate shot.

By the time you have worked your way through the stack, collection or folder you are working on, you will have identified the very best images in your collection. They will be easier for you to find when you start work in the Develop module, as you'll already know exactly which shots you can discard without any further processing.

Use the zoom slider below the Select image to enlarge or reduce each of your selected images. With Sync selected, dragging either one of them will move its partner in unison so that you can compare very specific parts of each image.

Surveying Images

The Survey mode (shortcut N) selects more images at once, and so doesn't allow for quite so methodical a workflow. However, you can still rate and flag images individually in this mode by clicking on them in turn and applying your changes. The one to which your changes have been made sports a heavy white border.

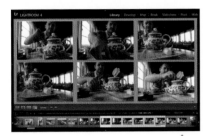

Perhaps the most valuable tool when whittling down your images in Survey mode, though, is the delete icon. This appears in the bottom right corner of an image as you hover over it, in the form of a white cross on a black box. Clicking this removes the image from your Survey selection, without removing it from your catalogue.

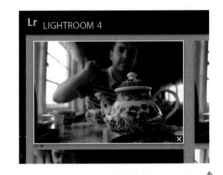

The Lightroom Survey view lets you select a greater number of images at once so that you can compare them as a group. The one to which your changes will apply has a heavy white border. In this case it's the first image on the top row.

You'll soon be able to identify images that you don't want to work with, so remove them from the Survey overview by clicking the white 'x' that appears in the lower right corner as you hover your mouse over them.

By systematically rating your images and removing those that don't make the cut you should soon be left with a small number of your very best images.

At this point you can either deselect them and move on to the next group, or you can apply a set of standard metadata. Use the regular metadata panel in the sidebar to the right of the screen and click the switch by the Sync button below it to apply all of your entered metadata to each of your selected images. You can do the same with the Keywords and Quick Develop panels to apply basic changes and filing data to your images before starting work in the Develop module.

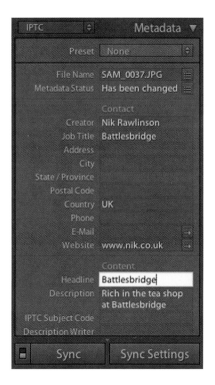

You can apply metadata, keywords and Quick Develop changes to selected images in the Survey view. Clicking the switch beside Sync will ensure that all changes are applied to each of the images as they are entered.

Organizing your Work into Collections

In the previous chapter we split our photos into folders when importing them to the Lightroom catalogue. This is a quick and very efficient way to break down your library and start to organize it into a more manageable, meaningful structure.

However, while these rather rough divisions may be fine on an abstract basis—allowing you, for example, to group a collection of images from Morocco in one easy-to-find location—they don't necessarily work on an editorial or project-focused basis.

For example, if you're working on a personal project on desert flora, it would make far more sense to gather together relevant shots from the US Mojave, Australian Gibson and Chinese Gobi deserts in one place to save you hunting through discrete American, Australian and Chinese folders to find them. Likewise, if you're a portrait photographer, you may want to gather together all of your best shots from the last 12 months to

build a portfolio for your website, regardless of which client you were shooting for when you created each one.

Lightroom lets you do this by grouping them into collections, which are folders referencing original and edited shots elsewhere in your library, so that they can be viewed side by side and quickly accessed for developing without you needing to navigate the rest of your catalogue. Collections don't duplicate your images—they are merely symbolic links—so an image can appear simultaneously in multiple collections without taking up any more than its original amount of disk space. This means that they aren't removed from their original locations on your disk.

Collections, which can be most accurately compared to playlists in a music application, are organized through the Library module where they appear in the left-hand sidebar. There are two types: Smart Collections, which gather together images that match set criteria and update on the fly as you add and classify new images in your library, and regular collections to which you add images manually.

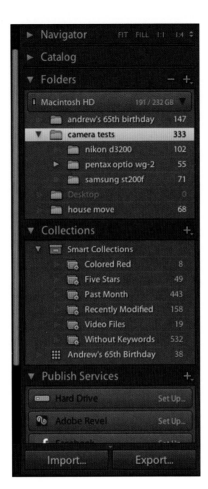

Collections can either be regular, manually updated groups of images, or so-called Smart Collections, which use metadata variables to gather together matching files and automatically organize them on the fly.

Regular Collections

Regular collections are built up by dragging and dropping their contents into a Collection container, but first you need to define that Collection by following this simple three-step process.

1.

Start by selecting the first images you want to add to your collection either in the Library module grid view or on the film strip in the Develop module, and then click the + button beside the Collections entry in the sidebar.

2.

Pick Create Collection ..., give your new collection a name and choose whether you want it to sit inside another collection. In the example above, where you might be collecting shots of desert flora, this would be useful if you wanted to further subdivide your collection by genus or color.

3.

Make sure the box to Include selected photos is checked and then click Create.

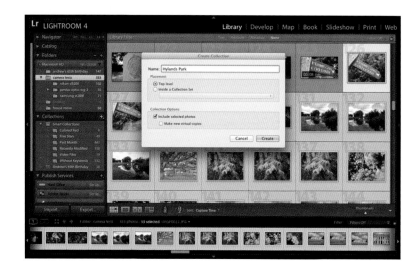

Creating your first Collection is a simple three-step process that gathers together your selected images into a group to which you can add further photos over time.

Lightroom will expand the Collections panel and create a new entry for your collection. As you continue working with your photos, you can add new entries to this collection by dragging them into it from either the Library grid view or the film strip.

To remove an image from a Collection, simply highlight it in the Collection's grid overview in the Library module and tap backspace. This takes it out of the collection, but leaves it in its original position in the catalogue. Because you're not actually deleting one of your assets from the library there is therefore no confirmation dialogue to check that you really do want to remove it.

Smart Collections

Where regular Collections are built manually, Smart Collections are maintained by Lightroom by matching the underlying metadata associated with each image to set conditions chosen by yourself.

Start by clicking the + beside Collections in the sidebar and select Create Smart Collection ... Give your Smart Collection a name and choose whether you want it to live inside a Collection set, then start defining the variables that your photos need to match to qualify for inclusion in the Collection.

Smart Collections update themselves on the fly in line with the criteria you specify at the point of creation.

By default the Smart Collection creator wants to start working with ratings, which is a logical move as you'll often want to isolate your best shots to work on. However, if this is irrelevant to your particular needs, pick an alternative from the drop-down menu and use the dynamic fields that appear to the right to set the variable that need to be matched. You might, for example, want to pick out only those pictures that have been edited (pick "Has Adjustments"), those shot in a particular location (use the GPS Data, City or Country options) or when it was shot (pick Capture Date, which you can set to a specific time, before a point, after a point, or falling within a range).

You can add as many criteria as you like by using the + button at the end of each metadata line to add a further line below it, in this way building a comprehensive list of conditions that will very effectively pick out a specific set of images. When you have added all of the criteria you need, click the Create button to drop the new Smart Collection in the sidebar.

As you continue to add images to your library and classify them by adding further metadata, the contents of your Smart Collection will automatically update on the fly.

Collection Sets

In the same way that we are able to create subsets within collections, you can create super

collections containing several smaller collections called Collection sets. These are differentiated from regular collections in the sidebar by using an archive box icon rather than a stack of photos, which when selected shows you the amalgamated contents of each of the constituent collections within it.

Create a Collection set by clicking the + beside Collections in the sidebar and selecting Create Collection Set ... and again giving it a name. You can now drag in your existing collections by dropping their icons on top of the Collection set's name within the Collections brick.

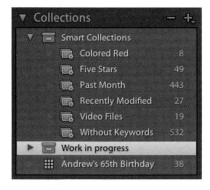

Collection sets can be used to organize your existing collections to save your sidebar becoming cluttered and over-run.

Default Collections

Lightroom ships with a number of default collections already in place. Each of these is effectively a Smart Collection, but only six of them appear in the sidebar's Collections panel, and it's only those ones that can be edited.

These default Smart Collections are "colored red," "five stars," "past month," "recently modified," "video files" and "without keywords." Each will help you find images you're likely needing to work on. "Without keywords", for example, will isolate images to which you should add further metadata; "past month" will isolate those that you have added to the library recently, and so are most likely to be working on, and so on.

Just because these were defined by Adobe, though, doesn't mean that you can't tailor them to your own needs.

If you work in a fast-turnaround environment, for example, where all images have to be processed and dispatched within a week, the "past month" smart collection won't be of much use to you, but a "past week" collection would. Rather than create a new collection for those images shot in the last seven days and have it sitting beside the redundant month collection, though, why not just rework Adobe's default set?

To edit a smart collection, right-click its entry in the sidebar and select Edit Smart Collection. This calls up the regular Smart Collection editing dialogue, complete with drop-down criteria selections. To resolve our monthly / weekly conflict we only need to change the drop down for "months" to "weeks" at the end of the only row in this Smart Collection, and change the name of the collection to "Past Week" so that we can easily identify it in the sidebar, then click Save.

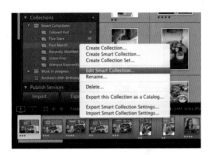

Lightroom has a handful of Smart Collections in place as soon as it's installed. You can edit them, or any you have created yourself, by right-clicking and picking the Edit option from the menu.

You might also want to redefine the Recently Modified smart collection if it doesn't meet your current requirements. By default this shows images you have worked on in the last two days, but if you only use Lightroom once every week or so you might want to change this to identify images edited in the last two weeks instead.

Target Collections and Quick Collections

If you're likely to spend your time working with one particular collection for the next few editing sessions, it makes sense to set it as a Target Collection. This feature appeared in Lightroom 2, and allows you to quickly add images to a Collection with a single key press, saving you the hassle of dragging and dropping them manually.

To set a Collection as a Target Collection, right-click its entry in the sidebar and select Set as Target Collection. You'll notice that Lightroom puts a + beside it. You can only have one Target Collection at a time, so if you apply this status to another one, the + will be removed from the collection you just set. You can also manually demote a Collection from being a Target Collection by right-clicking and un-checking the Set as Target Collection marker.

Now, as you work your way through your library, you can quickly add images to this collection by clicking them and pressing B.

Target or Quick in a Click

Hover your mouse over an image in the Library module and you'll see a spot in the top-right corner. Clicking this adds it to the Target Collection if you have one selected or, if not, to the Quick Collection.

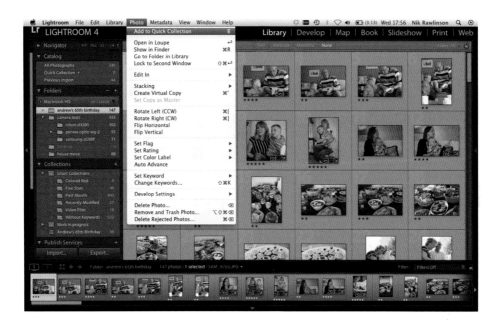

The Quick Collection lets you gather together images that you want to keep a temporary eye on, or which you'll want to add to another collection in your library at a later point.

Sometimes, however, you won't want to add images to a longer-term collection, but simply gather together a few shots that you need to work on right away. This is where the Quick Collection comes into play. You'll find this in the Catalog panel at the top of the left-hand sidebar.

As with the other regular Collections you can drag images into it to temporarily hold them for editing, in much the same way that you might jot down notes that you later want to compile into a written report.

If you don't have a Target Collection set, you can use the same shortcut—B—to add one or more selected images to the Quick Collection without having to drag them into place, or use the option at the top of the Photo menu in the Library and Develop modules, or on the Edit

menu in the Book, Slideshow, Print and Web modules. This lets you quickly build up a list of shots that you want to use or edit in whichever project you're working on without having to create a dedicated long-term collection.

Working with Locations and Maps

If you want to exploit your images commercially, the more you can tell a potential customer, photo library or publisher about where and when they were taken, the better your chances of making a sale.

Everyone can tell just by looking at what a picture shows in an abstract sense, but it often takes a little more information to know the full story. Without any defining landmarks such as the Eiffel Tower, Space Needle or CN Tower, a city skyline comprising nothing but anonymous-looking tower blocks could be anywhere in the world. Unless a photo editor has intimate first-hand knowledge of Manchester in the UK, Denver in

Colorado or Perth in Western Australia, it's unlikely they'd be able to pick out a shot of any of these places simply by looking at a photo. Neither would they have the time to sift through a library of un-plotted shots on the off-chance they come across what they need.

The first step in solving this problem is accurate and diligent tagging of your images with location names, which would allow the picture editor to search the library using freeform text and turn up a series of matching results. It will also allow you to perform a similar search at home when you want to filter down your collection to just a particular subset of images.

However, without putting your images into a more meaningful context you are still only telling half of the story. How would a US-based photo editor know what place names to search for when looking for a shot that would illustrate the undeveloped "green belt" surrounding London? How would his British counterpart quickly and easily find shots of ski resorts

surrounding Seattle if he didn't already know their names?

The answer is to plot your images on a map. By adding this further context to your work you enrich the metadata that underpins your work and make it both more useful and more saleable.

From a personal perspective, it also helps to highlight gaps in your portfolio. If you find yourself on assignment cataloguing Delhi and its environs, plotting your images on a map lets you see at a glance which parts of the city you still have to cover and helps you organize your workload on what might be a limited-duration excursion, or when you've been set a tight deadline.

Geotagging

The process of plotting your images on a map is known as geotagging—literally tagging your images with geographical data. This data consists of a pair of longitude and latitude coordinates that identify a unique intersection on the surface of the planet. Because no two pairs of coordinates will ever reference

the same spot, and because no single pair can ever reference more than one location, attaching them to your photos' metadata lets you accurately pin them to locations on a map, such as the one found in Lightroom's Map module, or on popular photo-sharing sites such as Flickr.

Many cameras—and particularly camera phones—automatically add this data to your images through the use of an internal GPS chip. This receives signals from a constellation of satellites on geostationary orbit around the planet. By comparing the incoming location data from each one, and an offset time signal, it can work out where it is in relation to each one, and thus where it stands in the world.

Images that are tagged in this way at the point of capture are automatically plotted on the Lightroom map. However, if your camera doesn't include such a chip you can manually plot them yourself, or import them alongside a GPS track and assign Lightroom to marry the two.

Map Types

Start by switching to the Map module by clicking Map at the top of the screen. You'll see that this calls up a regular Google Map. You can switch between the four regular Google Map types using the Map Style menu in the bottom-left corner of the interface's main pane. Road Map shows a vector-based plan of the overview area, with the level of detail tailored to the magnification setting; Satellite uses tiles of satellite imagery to display a bird's-eye view of the area; and Hybrid overlays the satellite view with vector graphics from the road map. Terrain uses different shades of green to show the lie of the land, again overlaying it with the road map.

The two other options in this menu—Light and Dark—are specific to Lightroom and present variations on the terrain view but in a muted monochrome color scheme, which can make it easier to spot your geo-located photos.

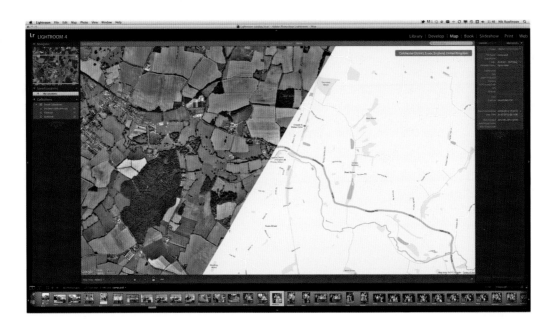

The various map styles—here, we've split the Hybrid and Satellite views—let you choose whichever graphic makes it easiest to accurately plot your images.

Plotting your Images by Hand

The simplest way to plot your images is to physically drag them onto the map. Start by using the search box at the top of the Location Filter line above the

map to search for the location where your pictures were shot. The map will center on your new location.

Use the scale slider beside the map type drop-down menu to zoom in far enough for you to be

able to accurately pinpoint either the spot where you were standing or the precise subject in the photo you want to place, and then drag it from the film-strip at the bottom of the screen into that location on the map, where it will be marked with an orange speech bubble.

If you took several photos in the same location, you can position them as a batch without having to drag them in one at a time—simply select the range containing each of the images you want to drop on the map and drag them as a group.

Changing an Image Location

It's all too easy to plot an image in the wrong location if you're not careful to zoom in to the most appropriate level or you mix up one spot for another. However, repositioning images is just as easy. To move a whole block of images that comprise an entire place marker, click the marker to select the images in your catalogue and then drag them from the film strip to their new location. If you only need to reposition a subset of pictures from that location, deselect the ones you don't need to correct before moving the ones that have been misplaced.

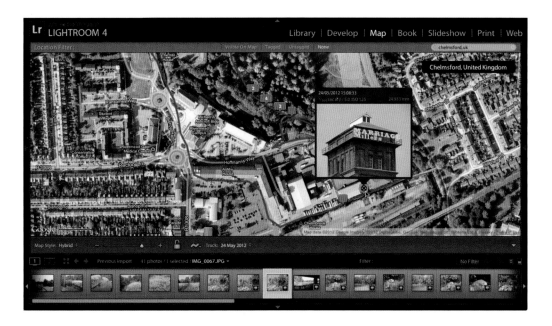

Relocating an image on the map is a simple matter of grabbing its marker and dragging it to a new location.

Plotting Images Automatically

Even if your camera doesn't have a built-in GPS receiver to stamp locations on your images at the time they are recorded, you can still automate the process of plotting them on the Lightroom map to a large degree once you return to your computer.

The secret is to record a track of your movements while out on your day's shooting, and import that into Lightroom when you get back to base.

Dedicated GPS devices can create such tracks, and there are several applications for use with a smartphone that will track your movements when you are out and about so that they can be downloaded on your return. Note that to do this they obviously need to remain active—although perhaps in sleep mode—and that because they are constantly using the phone's location features they will likely reduce the device's available battery life.

Lightroom uses the industry standard GPX format when working with tracklogs, so make sure that whichever application you use to record your movements can write and export that format.

Once you have recorded your track, download it to your computer and import your images to Lightroom in the usual manner. Switch to the Map module, and check that the subset selected above the film strip at the bottom of the screen is Previous Import. If it isn't, select this from the pop-up menu on the black strip above the film-strip.

Now you need to import your GPS track. Click the track icon further along the same bar, which looks like a horizontal zigzag and select Load Tracklog … then navigate to your downloaded log. Lightroom will import your track and display it on the map using a blue line that should match your route.

Even if your camera doesn't have an internal GPS receiver you can still task Lightroom with plotting your photos by importing a track file created by a regular GPS device.

You now need to plot your images on the route. Lightroom does this by comparing the timestamp of your images with the timestamp of each waypoint in your downloaded GPS route and positioning each image on the route at the matching time-code, in the process plotting them on your map.

If your GPS device and camera aren't set to the same time, perhaps because you are travel-ing and haven't updated one of your devices, you'll need to correct the timezone offset on your tracklog to match your pictures. Do this by clicking the track icon again and selecting Time Zone Offset ... then drag-ging the slider or typing in a number to set the device clock forwards or back from its current position. The smallest degree by which you can change it is 0.1 in either direction—effectively a tenth of an hour, or six minutes.

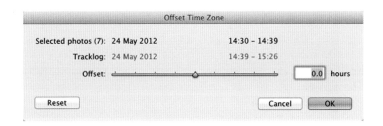

It's important to ensure that the clocks in your camera and GPS device are set to the same time if you want to plot your images accurately. If they aren't, correct the offset in Lightroom.

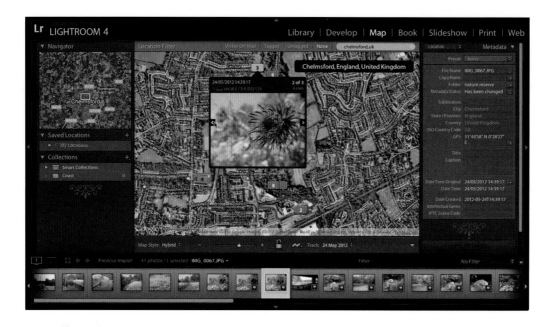

Once you have placed an image on the map, hovering over the speech bubble will cause it to pop up so that you can preview it. If you've placed several images in the same location you can scroll through the group using the left and right arrow buttons that overlay the image previews.

Extending your Location Metadata

You'll notice that as soon as you drag a photo into a particular location on your map Lightroom populates the Location metadata view in the sidebar. If you don't have this visible, expand the sidebar and use the drop-down menu at the top of the channel to select Location.

This data includes, at the very minimum, the GPS coordinates of the location where you dropped the image. If you're viewing the metadata in the Library module, clicking the arrow beside this will take you directly to the Map module with the map centered on that spot.

However, as GPS data isn't particularly easy for humans to understand (most know that the Greenwich Meridian—longitude 0—runs through London, but beyond that these grouped numbers may be a mystery) it also has fields for sublocation, city, state/province, country and ISO country code. Lightroom fills out each of these as best it can using human-readable entries drawn from the maps server.

The process of formulating these additions, which effectively translate the technical data, is known as reverse geocoding, since Lightroom is deriving the coded plain-English names for places from the geographic data. It does this to a very fine degree, but if you want to make it even more accurate you may want to tweak the results yourself, perhaps adding in a missing sublocation or using a more relevant local name for a particular place.

When you position your image on the map, Lightroom populates the location fields in its underlying metadata. You can expand this data by adding your own entries.

Take care when doing this that you don't introduce confusion by using names that would be meaningless to picture editors, or are subject to dispute. For example, should you visit Burma/Mayanmar, think carefully about whether you want to use the former of those two names, which is common in the United States, United Kingdom, Australia, Canada and many other countries, or the latter, which is the accepted name in Germany, Norway, China, India and Japan. Using the country's full name—the Republic of the Union of Myanmar—could introduce further confusion.

Likewise, the ISO Country Code field might not reflect your preferred styling for the country in which your image was shot. By default, images shot in the United Kingdom are tagged with the code GB, which is at odds with the country's official top-level Internet domain .uk (the United Kingdom can also use .gb, but doesn't). UK is reserved for the United Kingdom in the ISO country code database to prevent any other country from using it, so as to avoid confusion, but it is not used. You can find a full list of the currently adopted country codes on the International Standards Organization website at http://www.iso.org/iso/country _names_and_code_elements

Because of the confusion that can be wrought by straying from the accepted industry standards, we would recommend sticking with Lightroom's default reverse geocoded data, as supplied by Google Maps, unless you have a very specific need to amend it.

Descriptive Data

Sometimes knowing where a picture was shot is only half the story, though. Again, consider the photo editor who might one day want to buy your images and you'll soon realize that when presented with a list of shots taken in Berlin, finding the precise orientation and subject matter among them would be a long and tedious job without further tags on which he or she can filter the list of options.

This is where Intellectual Genre and IPTC Scene Code come into play, which describe not so much where an image was taken, as what it contains.

Intellectual Genre is most often used for written content such as obituaries and advice columns rather than photos, and describes the actual subject matter and even whether or not it is an exclusive. There are no specific genre codes in the IPTC genre vocabulary for photography (see http://cv.iptc.org/newscodes/ge nre/), so this field should be used with care but photographers can still put it to some use by following the conventions outlined for written content to tag photographic material that could be used to illustrate or accompany

text-based content falling into each specific genre. For example, shots of famous people could be marked with code Obituary, to be used following the subject's death, while Retrospective might be used to tag scanned historical images.

The IPTC Scene Code field, which sits below this in the Location Metadata panel is far more relevant to jobbing photographers as it relates directly to imagery. This describes the overall composition of the photograph, such as landscape, couple or under water, which when used with the geocoded location data above will help photo editors who want to buy your work—and you, if you have a large library—to zero in on specific shots in designated locations, such as couples in Paris or landscapes of the American Mid-west. A full list of scene codes is detailed on the IPTC website at http://cv.iptc.org/news codes/scene/

Useful Geographical Data Code Links

International Standards Organization
Country Codes: http://www.iso.org/iso
/country_names_and_code_elements

IPTC Genre Codes: http://cv.iptc.org/n
ewscodes/genre/

IPTC Scene Codes: http://cv.iptc.org/n
ewscodes/scene/

Searching for Geolocated Images

Once you have placed your images on the map, you can use their locations as an additional variable on which to search for them.

Start by isolating only those images you have placed by selecting All Photographs from the status bar above the film strip, then use the Location Filter line above the map to select Tagged. This dims all of the images in the film strip that you haven't yet assigned to a location. The other options are self-explanatory, with None clearing the filter so that none of the film strip images are dimmed, Untagged dimming those you have placed so that you can quickly identify only those images that you still need to position, and Visible On Map.

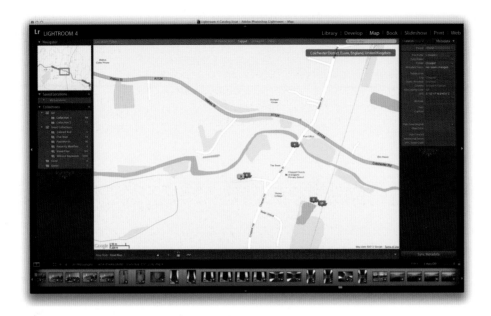

Once you have positioned your images on the map you can use their tagged status as a search criterion on which to isolate them.

Visible On Map is the only option that actually changes the number of images displayed in the film strip—whether dimmed or not—so is a quick and easy way to zero in on just those pictures that fall within your current field of view.

You can then drag the map around, and if you've selected Visible On Map the range of images in the film strip will adjust dynamically to show the ones that still apply. If you have selected Tagged, on the other hand, dragging the map won't change the range of images displayed in

the slip, but will allow you to skip straight to the relevant part of your catalogue by clicking on the marker bubbles.

Searching by dragging is a very inefficient way of navigating your catalogue, though, and you would do far better to use Lightroom's built-in metadata

search tools to narrow down your collection along more organized lines.

Return to the Library module by clicking Library at the top of the screen and then use the drop-down menu on the far right of the Library Filter row at the top of the interface to select Location Columns.

This breaks down the locations to which you have assigned your images to finer and finer degrees, starting out at the whole country level and narrowing to specific locations. By working from left to right and clicking the appropriate option in each column you will eventually be left with just those images that were taken in the location you need to identify, with all others hidden.

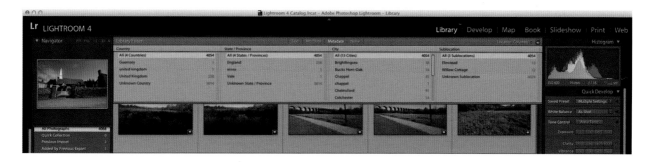

You can use the metadata columns in the Library module to drill down through your location metadata to isolate particular images without having to navigate the map.

Chapter 4: The Edit

ALTHOUGH LIGHTROOM DOESN'T offer the spectacular range of tools that Photoshop does, its Develop module still contains every tool you need to take your images from good to great. From sharpening images to adding contrast and more punchy colors, to workaday jobs such as fixing white balance or removing dust spots, Lightroom covers all the basics you could want to help you create finished, realistic images. Those looking for more stylized images needn't fret, either, as you can create convincingly filmic effects in seconds. Best of all, because Lightroom is all about speed, once you've found a collection of settings you like, saving it and using it on batches of images in the future is a snap.

Key Points in this Chapter

In this chapter, we'll investigate Lightroom's arsenal of editing tools, which cover all the jobs most photographers need to do. We'll look at fast fixes for common problems, such as repairing inaccurate white balance, misjudged exposures and cropping and rotating images to get the composition just-so. We'll also see how Lightroom can fix the flat-looking images that DSLRs often create, through its curves and saturation tools. Finally, we'll see how Lightroom's ability to create edit presets can help you edit and finish scores of images in mere minutes.

Basic Editing

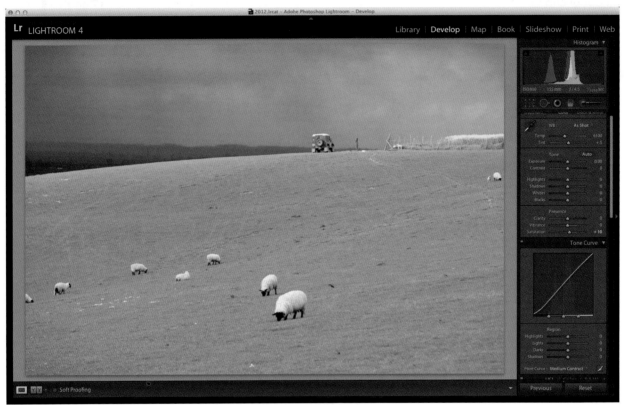

Lightroom's basic editing panel is all about changing the overall look of your image, rather than fixing localized or minute problems. Fundamental issues, such as images that are too bright or too dark, or have the wrong white balance, can be tackled here.

There's a surprising amount of power, though. If an image is too dark, you can restore detail to its shadowy areas by pulling the exposure slider to the right. However, if your image is well-exposed but has, for example, an over-exposed white sky, you can pull the Whites slider to the left, which will reduce the tones in your image, while preserving the relationship between other tones in the image. In earlier versions of Lightroom the Recovery slider is roughly equivalent to the Highlights slider in Lightroom 4, with the Highlights slider gaining the ability to brighten highlights.

Below the tone controls is a set of controls marked "Presence". These controls affect how much "oomf" your image has. For example, the Clarity slider adds contrast and sharpness to the mid-tones in your shots, while Saturation makes colors bolder across the board—useful for the relatively flat RAW files that most DSLRs create. The Vibrance slider is similar, but it attempts to detect colors in your image that are already well-saturated and avoids making them stronger, instead only making dull colors bolder. The Vibrance slider also allows you to boost the saturation in your image while leaving skin tones relatively untouched and natural-looking.

Hold ALT (OPT on Macs) when moving the Highlight, Shadow, Whites and Blacks slider to view only the highlights or shadows in an image.

Lightroom's basic
editing panel allows
you to quickly
correct an image,
as shown in this
before-and-after
shot.

Before

After

Cropping

Cropping an image can make all the difference. For all the care you might have taken behind the camera, being able to enlarge a subject by cutting out unnecessary bits of the frame is a tool almost as old as photography itself.

Cropping in Lightroom can take the shape of wholesale changes, such as changing an image's orientation from landscape to portrait, or it can be far more subtle, such as rotating

Want to try multiple crops of the same image? Press CTRL (CMD on Macs) + ' (the apostrophe symbol) to create a virtual copy of the original image.

Press CTRL (CMD on Macs) and click to draw a straight line across your image. This line will be the new, straight horizon in the final image—useful for wonky horizons.

a landscape image slightly to correct a squiffy horizon.

Lightroom makes rotating and cropping simple. You can select the cropping tool immediately under the histogram, or those looking to work fast can simply hit "R". This lays a grid on top of your image to help with alignment. You can click and drag the image from any of the corners or edges to make the image smaller, or click anywhere outside the image to rotate it. Once you've resized the frame, you can reposition your image within it by clicking inside the grid and dragging.

By default, Lightroom resizes your image so it's the same shape (aspect ratio) as it was when you took it. If you want something different, click "Aspect" and choose 4:3, for example, to have the final image fit on an iPad, or 16:9 for it to fit on an HD TV.

The cropping icon allows you to change the size of an image while keeping the original aspect ratio. Alternatively, you can choose entirely new image dimensions.

Original image

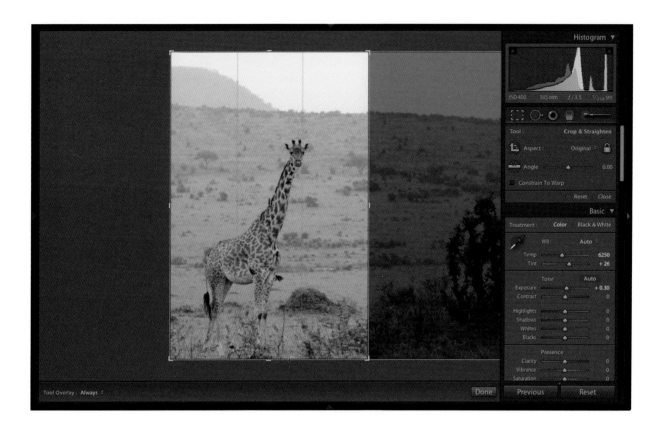

Cropping in process

Final image

Removing Dust

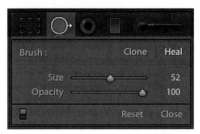

Dust is a fact of life for all photographers, but nature photographers get it worse—a life outside in hard environments can be tough on both your photographs and your kit, and the necessary evil of changing lenses outside means you'll often find specks of dust upsetting your images. The problem is worse on images taken with smaller apertures such as landscapes, but Lightroom anticipates the problem and gives you a very quick way of invisibly removing dust spots.

We'll concentrate on dust spots here, but Lightroom's healing brush is also a very powerful tool when it comes to sorting out skin blemishes such as spots and moles. The theory and practice is the same; the diplomacy of explaining to your subject what you've done is different!

You can quickly access the dust removal tool by hitting "Q."

Step #1

This image is finished in terms of color correction, but the big dust spots towards the right top and bottom need sorting out. Enter Lightroom's Develop module and press Q. The options available are the Clone and Heal brushes—the Healing brush is the more intelligent of the two, as it tries to blend nearby pixels over the top of the dust spot you're removing. The clone tool works best when used near the edges of an image.

Step # 2

Size the clone tool so that it's slightly larger than the dust spot you're trying to eradicate. On totally featureless parts of your images—solid colors and so on—you can simply click and forget. Here, the brush is cloning bits of detail over the top of the dust spot, which looks strange. When this happens, keep the mouse button down and drag the clone brush until it lands on part of the image that blends seamlessly.

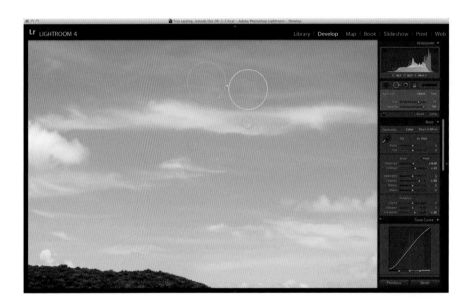

You can change the size of the clone brush with the Size slider in the right-hand pane, with your mouse's clickwheel, or with the [and] buttons.

Step # 3

Repeat the process on each dust spot in the image. If you're working with a series of images with identical dust spots you can automate the process somewhat, but check every image carefully to make sure each cloning operation "makes sense" and hasn't left artifacts lying around. Even slightly clumsy changes will be very obvious once you've printed your finished image.

Batch Editing

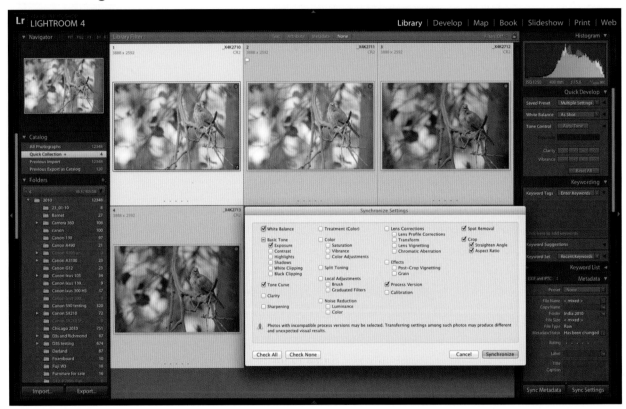

One of Lightroom's greatest strengths is its ability to help you breeze through a set of photos, refining, picking and rejecting as you go. This ability to batch process speeds things up enormously, allowing to bring dozens of images up to standard in just a few clicks. With other editors, for instance, if you shot a burst of 20 images, all under-exposed by a stop, you'd have to go through individually and correct each one. Even in Photoshop you'd have to write an action.

In Lightroom, it's possible to make changes to a single image, then apply those changes to as many images as you want to select. For example, if your camera constantly gets white balance wrong, you can reset it on one image, then change a hundred other images to the same color temperature, all in a matter of seconds.

There are two ways to sync editing changes in Lightroom. The first is to use Auto Sync. To do this, select more than one image in the Filmstrip at the very bottom of the screen (pressing F6 will show it if it's hidden). Then, select the small Auto Sync radio button or press OPT (or ALT), CMD (or CTRL) and Shift together. Now, any change you make to the image currently in the large main viewer in the middle of the screen will be made to the other images selected. Obviously this is something of a blunt instrument; the other way to make changes en masse to your images is to edit one, then select a series of other images, either in the filmstrip at the bottom of the screen or in the grid view in the Library module. Then, click Sync (or Sync Settings in the Library view), and choose which edit functions you want to repeat. For instance, you might want to synchronize exposure and saturation adjustments, but not dust spots or crop changes.

The Synchronize Settings dialogue allows you to choose which changes will be made to a series of images.

Batch editing doesn't reduce the need for you to carefully check each image for flaws before declaring it finished! Just because an edit works on one image doesn't guarantee it will work for a similar one.

Graduated Filters

The graduated filter is Lightroom's genius solution to the problem of landscape photos with over-exposed skies. In many, if not most landscape photos, the sky is brighter than the earth below, and that means you must choose between a sky that's too bright or ground that's too dark. In the old days, you could compensate for this with a glass graduated filter, which went from dark at the top to light at the bottom, and meant you could expose for the ground in your camera and the sky would be darkened by the filter.

The problem is that graduated filters are expensive, and you might need more than one, possibly several, to cover all eventualities. Fortunately Lightroom allows you to get more or less exactly the same result, without fiddling around with fragile, expensive pieces of glass.

The graduated filter (the shortcut key is M) can affect a wide range of image settings, but the ones you're likely to find most useful—particularly in nature and travel photography—are exposure, saturation and brightness. Select it and click on the top edge of your image, then drag down. The result is a filter that starts strongly at the top, then fades to normal at the bottom. The larger your filter the more subtle the effect will be: for example if you only pull the filter across half your image, its effect will be more noticeable.

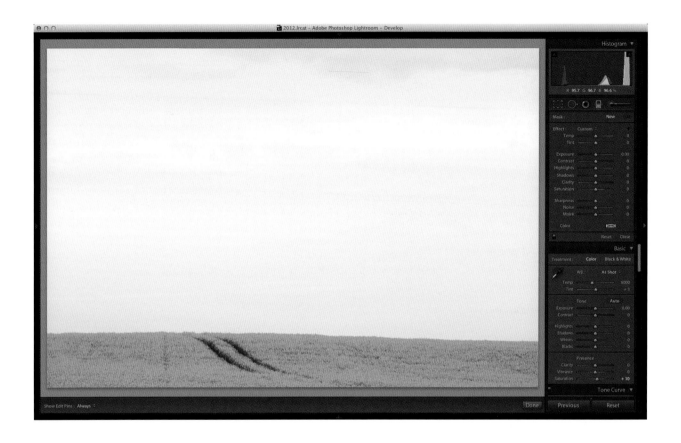

The lower third of this image is well-exposed, but the top part looks rather flat and featureless. The graduated filter will help out.

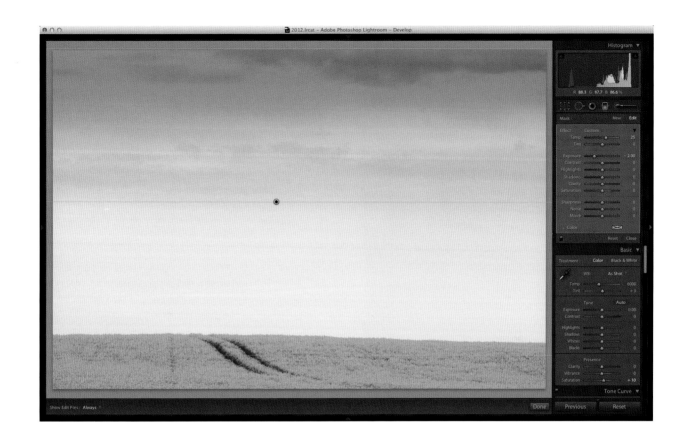

Pulling a graduated filter down and setting it to reduce exposure has resulted in more detail and color in the sky and clouds.

White Balance

To produce images with accurate colors, your camera has to detect the kind of light it's working in: different kinds of light bulb or cloud cover can affect the white balance in an image, and when the camera gets it wrong—which it will—the result will be an image that looks too warm (orange) or cool (blue). The in-camera way to fix this is to set white balance manually, but this takes time, is fiddly if you're wearing gloves, and in some cases requires a piece of reference white card if you're picky about accuracy.

However, if you shoot in RAW, you can change the white balance of an image without destroying any detail in a photo, and, unsurprisingly, Lightroom makes life simple.

You can adjust a wide range of color and brightness settings with each graduated filter you need.

Image still not working? You can use more than one graduated filter to fine-tune your shot.

Step #1

The snow on the ground and overcast skies have conspired to fool our camera into shooting a much cooler white balance than needed, with the result that the image has picked up a distinct blue hue. Fortunately, correcting the color cast takes a matter of seconds. The easiest way to do it is to use the white balance chooser at the very top of the Basic panel in the Develop module; simply pick the kind of light you were shooting in (day-light, cloudy and so on) and your image will come closer to reality.

Step #2

One size doesn't always fit all, though, so another option is to click the white balance slider and drag it from left to right. The left hand of the slider is for setting cool white balances, the right hand side warmer. If your image picks up an additional color cast when you correct white balance, the Tint slider below can help correct it.

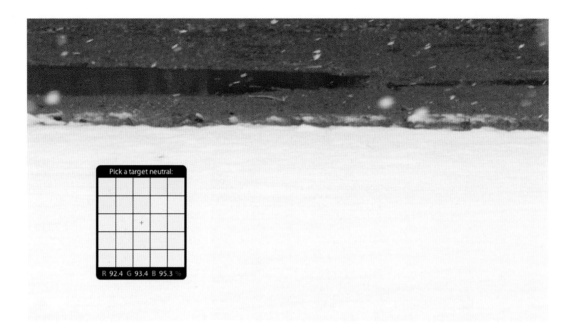

Pick a target neutral:

R 92.4 G 93.4 B 95.3 %

Step #3

By far the best way to quickly correct white balance in an image is to use the white balance selector. Simply tap W at any time and the mouse pointer turns into an eyedropper. Find a neutral, light grey area of your image—this, with its snowy foreground, is a good candidate—and click the eyedropper on it. As you move the eyedropper over the image an enlarged view of the area you're hovering over appears, to help with accuracy.

Finished version of the image.

Adjustment Brush

Historically, Lightroom wasn't the best option if you wanted to make changes to small parts of your images—its strength was in making fast, effective, whole-picture edits. However, starting with version 2, the localized adjustment brush allows you to edit small parts of your image, which is useful, for example, if a small part of your image is very bright and needs its exposure reduced, but the rest is exposed correctly.

With subsequent versions of Lightroom the localized adjustment brush has gained features and power. In Lightroom 4, the adjustment brush can change color temperature and tint, as well as editing only highlight or shadow tones. It can also be used to reduce noise.

Big Ben's clock face is far too bright— the localized adjustment brush will step in and save the day.

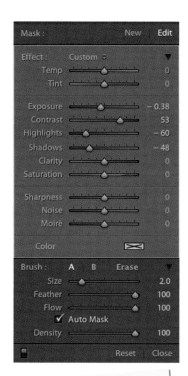

The adjustment brush isn't a one-trick pony—you can alter multiple aspects of a selection at once. If you find a particularly useful combination of settings, click Effect at the top of the panel, then Save Current Settings as Preset.

Press K to select the adjustment brush, [and] to change its size, and O to highlight areas you've worked on in pink. Pressing A will help you stay within the lines in your image.

This image doesn't require wholesale adjustment, so the adjustment brush is the perfect alternative to loading Photoshop.

Presets

With so many editing options to choose from, producing exactly the effect you want in Lightroom can take some time. And, while you can replicate that effect across several images using the Sync button, every now and then you'll find a treatment for your images you want to use again and again.

This might be something simple, such as a curves adjustment and sharpness addition that you know works particularly well on one of your lenses, or it might be a more dramatic edit designed to give your images a certain style—think Instamatic-style processing, or heavily saturating an image and giving it a dramatic, eye-catching vignette.

When you come across a combination of settings you simply can't be without, you can save them as a preset. The Save Preset menu is very similar to the dialogue box you get when synchronizing edits across a number of images—you're given the option of syncing every edit available, or you can cherry-pick the ones appropriate to the look you're after.

If you don't want to spend time crafting your own presets, there are hundreds available online, many for free. A simple web search for "Lightroom presets" will set you on the right path.

This image has been given a retro look with a preset which changes multiple settings at once

New Develop Preset		
Preset Name:	Split-tone green	
Folder:	User Presets	⬍

Auto Settings

☐ Auto Tone

Settings

☑ White Balance ☑ Treatment (Color) ☑ Lens Corrections
 ☑ Lens Profile Corrections

☑ Basic Tone ☑ Color ☑ Transform
 ☑ Exposure ☑ Saturation ☑ Lens Vignetting
 ☑ Contrast ☑ Vibrance ☑ Chromatic Aberration
 ☑ Highlights ☑ Color Adjustments
 ☑ Shadows ☑ Effects
 ☑ White Clipping ☑ Split Toning ☑ Post-Crop Vignetting
 ☑ Black Clipping ☑ Grain

☑ Tone Curve ☑ Graduated Filters ☑ Process Version

☑ Clarity ☑ Noise Reduction ☑ Calibration
 ☑ Luminance
☑ Sharpening ☑ Color

[Check All] [Check None] [Cancel] [Create]

The New Develop Preset box allows you to save various settings for later use. Simply check the settings you want to keep, give your preset a sensible name, and you can come back to it whenever you like.

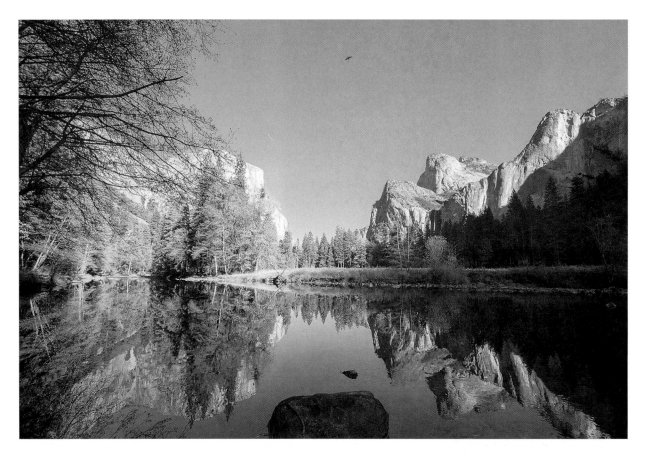

Here, a black and white preset has been used to convincing effect.

History

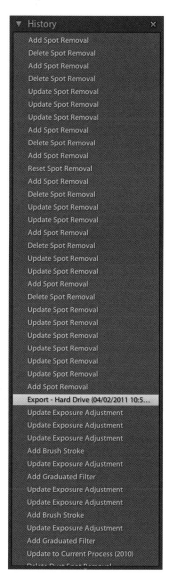

Lightroom's history list allows you to step back through the DNA of any of your images.

Lightroom's non-destructive, metadata-based approach to image editing is a gift that only becomes more valuable as time goes on. Unlike other image editors, Lightroom maintains an image history that persists for as long as the file is in your library. For instance, that means you can completely reject all the changes you've ever made to a shot by pressing CMD (or CTRL, in Windows), Shift and R.

Alternatively, you can step back through the history of your file. Show the left-hand pane of the Develop module (or press F7) and the history of your image is listed below Presets and Snapshots. From top to bottom, Lightroom lists all the changes you've made, from the most recent to the date your file was originally imported to your catalogue. Times you've exported your image are also listed.

Reverting your shot back to a previous state is as simple as clicking the edit—so if your image is now too heavily saturated, you can find the time you made that edit and remove it. However, if you go back in time and undo an edit, the next change you make will delete all the other changes you made. The best way to keep your options open is to use Lightroom's Snapshot feature. To do this, either click the + icon next to Snapshots, or press CMD (or CTRL) and N. Now, no matter what you do to either your image or its history, you've got a fail-safe version, complete with an independent history.

Creating snapshots allows you to jump quickly to any stage in a shot's history.

An image like this might go through a dozen small edits before export—history allows you to track its progress and retrace your steps.

Sharpening

Lightroom's detail panel is a subtle affair—it's where you control both sharpening and noise. At its most basic, sharpening increases contrast on the edges in your image, making them appear more defined and your image more crisp as a result. Those after a quick fix can use Lightroom's two supplied sharpening presets, but, since every image is different, it makes sense to get used to doing it yourself.

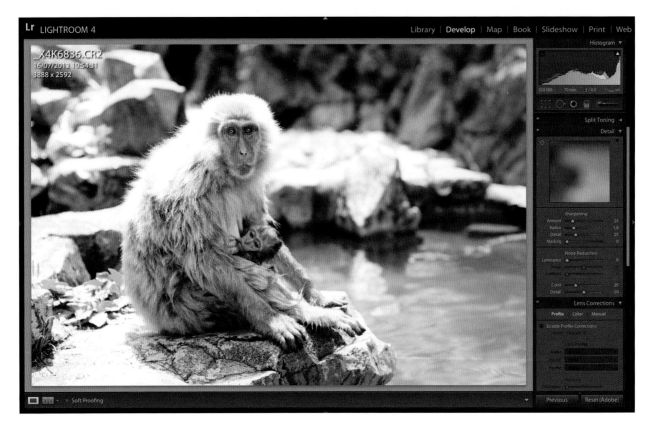

The detail panel allows you to fine tune the most subtle parts of your images.

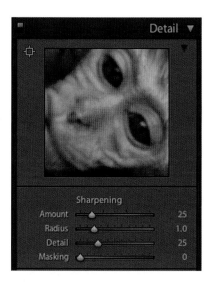

Presets are available for those in a rush, but the various sliders are easily understood and offer much more control.

The Amount slider is the master sharpening control, affecting how strongly sharpening is applied. There's a reason the slider turns red at the end—apply too much sharpening and you risk introducing unnatural textures into your image, as well as bright halos that make the subject of your image appear as if it's glowing. The next slider—Radius—affects how much of the area around the edges in your image benefits from sharpening. If your chosen Sharpening Amount has produced a halo, reducing the sharpening radius will help. The Detail slider is used to reduce the effect sharpening has on your image: at a low setting sharpening is applied primarily to high-frequency—that is, very well-defined—edges. Turned up, sharpening affects much more of your image. In a similar vein, the Masking tool allows you to restrict the areas of your image sharpening is applied: turn it up and flatter areas—such as an area of skin in a portrait, or a calm, reflective lake, will be masked out and sharpening will not be applied. This is a good way of stamping out the artificial textures sharpening can sometimes introduce.

Always, always apply sharpening with your image zoomed in to 100 percent. Sharpening is a very subtle tool, but being heavy handed with it will result in odd-looking prints.

When using the sharpening sliders, hold ALT (OPT on Macs) to show only the edges in your image. This will give you a good idea of how sharpening is changing your shot.

Noise Reduction

This shot of Mount Fuji at night was taken at ISO 2000, so a little noise reduction allows us to tread a careful line between graininess and detail.

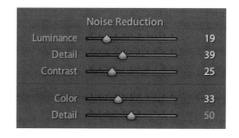

Noise and image grain is a fact of life for all photographers, but photographers shooting action and wildlife will find themselves reaching for higher ISOs more often. There's no need to be dogmatically anti-noise—a bit of grain in a photo can lend a shot a little realism, and heavy-handed noise reduction will leave a shot flat and devoid of sharpness.

For the purposes of Lightroom there are two different types of noise: luminance noise, which is simply grain, and chroma, or color, noise, where the grain in your images is random colors. Of the two, chroma noise is the hardest to live with as it's more unnatural looking. Lightroom's noise-reduction sliders are split into two groups: one for luminance and one for color noise.

The topmost slider in each is the amount of noise reduction that will be applied: the further the slider is dragged to the right, the more noise control is added. The detail slider attempts to preserve fine detail in a shot. Slide it to the right and Lightroom will try to keep sharp edges and fine textures intact, although in practice this generally means a slightly noisier image. Finally, the contrast slider tempers how much contrast is removed from your image: slide it to the right and Lightroom tries to preserve the contrast in your original shot—again, this comes at the risk of slightly increased noise.

The "Color" noise reduction slider works in a similar way, directly controlling how strongly noise reduction is applied. Again, the detail slider is for preserving fine detail once you've chosen how much noise reduction to use.

As with sharpening, noise reduction is easy to get wrong, so apply it with your image zoomed in 100 percent.

The Lens Corrections Panel

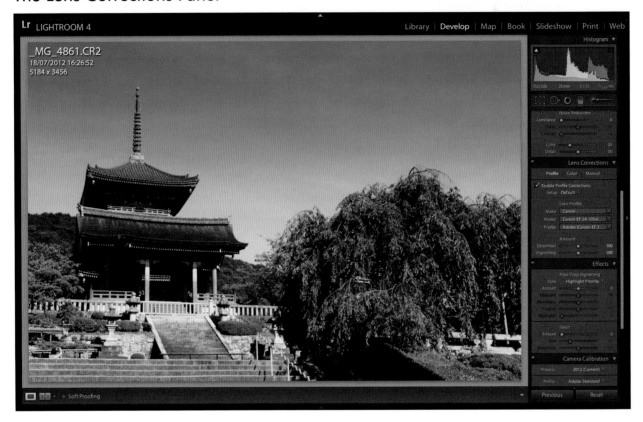

Many wide-angle lenses require a little geometric correction to prevent barrel distortion.

Every lens you'll ever use, from the kit lens that came with your DSLR to a thousand-dollar professional model, has imperfections. Some lenses distort your subject or introduce darkened corners to your frames (vignettes). Others introduce chromatic aberration such as purple fringing to high-contrast edges. Some of these problems—particularly purple fringing, are only particularly noticeable once you've printed them, meaning keeping an eye out for problems should be part of your workflow with every image you process.

Lightroom's Lens Corrections panel is a good way of staying on top of troublesome kit. Lightroom ships with hundreds of lens profiles for various camera and lens manufacturers, from mainstream models from Canon and Nikon, to third-party lens makers such as Sigma and Tamron, to more exotic kit from medium-format manufacturers such as Hasselblad. Check the Enable Profile Corrections box and Lightroom will automatically select a profile correction based on an image's EXIF data. The difference between your original shot and Lightroom's correction will be immediately obvious, but the distortion slider beneath allows you to fine-tune the changes Lightroom's made to the geometry of your shot, while a vignetting slider lets you brighten or darken the edges. The drop-down box next to "Setup" lets you save your customizations as a new lens profile.

The Color section of the Lens Correction panel is a very useful one, given how many lenses suffer from purple fringing. In many cases, simply checking "Remove Chromatic Aberration" is enough to fix an image, but the color picker, which allows you to click on the discolored edge and desaturate it, is another useful tool.

Chapter 5: Creating a Photo Book

POSTERS AND PRINTS may have the most immediate impact, but with a little more effort you can turn your photos into something truly special. Photo books, which are new in Lightroom 4, let you gather your best shots into an attractive bound publication, using built-in templates to simplify and speed up the process.

Lightroom hooks directly into the ordering system of Blurb, an online digital printer. It uses Blurb's pre-defined page sizes, along with a series of its own ready-made layouts into which you only need flow your photos. Once created, pages can be sent to Blurb directly from inside Lightroom, and right through the process it'll keep you updated with an estimated cost of your finished publication.

Just because Blurb is the only supplier integrated within Lightroom doesn't mean you have to use its services, though, as Lightroom also gives you the option of exporting your pages as PDFs or JPEGs for printing at home, sending to an alternative print shop, or emailing to a client for their approval on a third-party project.

Key Points in this Chapter

In this chapter we'll cover the process of creating a book from end to end. We'll show you how to lay out your images using the standard page sizes, automatically flow them into the publication and then tweak the image order and page layouts using the integrated cell-based designs. We'll add text to the pages to caption and expand upon the photos before preparing them for approval and publication.

Selecting Your Shots

The luxury of a photo book is that you can include a far larger number of images in your product than you can if you print a photo or poster. In this respect books are closer to a Web gallery, but with all the tactile benefits of a glossy coffee-table book.

They're not cheap, though. The process of creating a bespoke bound book, complete with cover and flyleaf pages, is time- and resource-intensive, so producing one costs considerably more than printing an equivalent number of individual stills.

For this reason you need to be just as careful when choosing the pictures you want to include in your book as you are when ordering a canvas from your local print shop. Before starting work, therefore, you should spend some time isolating your best shots and performing whichever adjustments you deem necessary in the Develop module. Think carefully about how your colors appear in each image, and what your pictures will look like when positioned beside one another on a spread. Try to match subject matters, as well as the level of texture, detail and tone in your shots so that each spread of pages works as a whole, rather than giving the appearance of being two or more images randomly pasted side by side. It also helps to fill out captions in the image metadata before you go any further (see p.118) as these can be used in your book, as we'll show you later.

Once you've selected the shots you want to use, gather them into a collection (see p.45) so that you don't have to sift through your complete library when it comes to putting them on the page.

With the Collection selected in the Library sidebar and its contents visible in the Film Strip, click the Book module at the top of the screen.

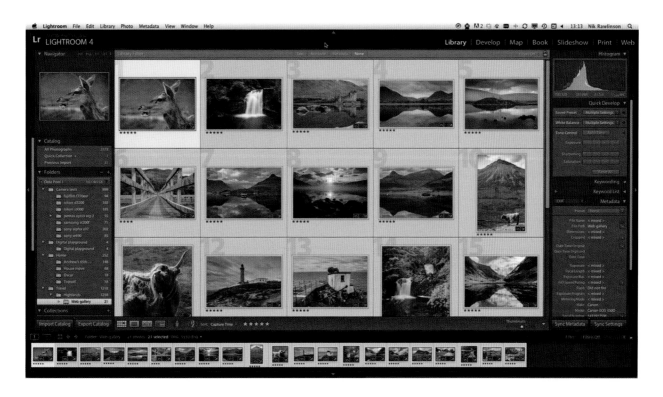

The process of laying out your book will be quicker and less confusing if you first gather together the images you want to use into a separate collection. The minimum accepted resolution for the images you use in your books is 200ppi (pixels per inch). Images that don't meet or exceed this threshold are marked with an exclamation badge in the top-right corner.

Choosing a Book Size and Media Type

At the time of writing, Lightroom offers very few options when it comes to choosing your book size. You're restricted to just five options that match book sizes offered by Blurb. Even if you choose not to print your book directly, but instead opt to export it as a series of PDF or JPEG pages, you can still only choose from the same five options, so you'll need to find a print shop that can work with Blurb's standard sizes if you want to get it printed elsewhere.

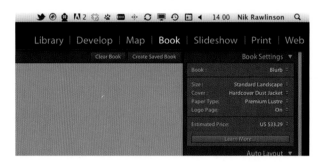

Lightroom has been pre-set with book sizes that conform to Blurb's existing photo book layouts.

Choose your book size using the drop-down menu in the Book Settings panel and Lightroom will draw the appropriate-sized blanks in the main editing window. Don't worry if you later change your mind, as you can go back and change it—even if you've started laying out your book—and Lightroom will resize your pages to fit. However, you need to be aware of the fact that changing orientation or aspect of your pages, such as square to rectangular, or portrait to land-scape, means your images may not fit the pages as well as they previously did, and you could be left with some blank spaces surrounding them unless you change the padding or zoom.

The remaining settings in the Book Size panel adapt to match your chosen method of output. If you're happy to print your book directly with Blurb you can choose the media type, whether or not you want to display a logo advertising Blurb and Lightroom on the back page, and the kind of cover you'd like. The latter options run to soft cover, printed hard cover, or a dust cover wrapped around the book.

Lightroom already knows the best way to optimize your images for Blurb's printing process, so the remaining options concerning sharpening, quality and

resolution don't appear if you've chosen to send it directly to Blurb. If you switch to PDF or JPEG as your chosen output type, though, they appear within the same panel, alongside a sharpening scale—low, medium and high, for enhancing contrast definition—and a generic media type selector handling glossy or matt pages.

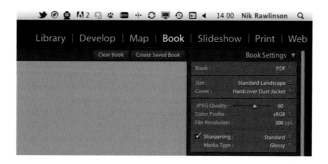

If you choose to save your book as a series of PDF pages or JPEGs you can also specify the degree of image compression, sharpening and a generalized media type.

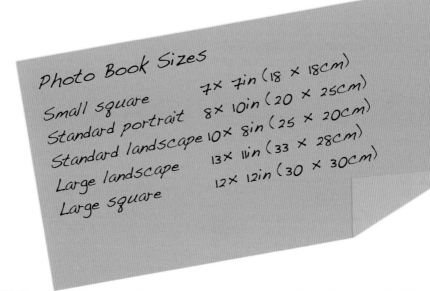

Photo Book Sizes

Small square — 7× 7in (18 × 18cm)
Standard portrait — 8× 10in (20 × 25cm)
Standard landscape — 10× 8in (25 × 20cm)
Large landscape — 13× 11in (33 × 28cm)
Large square — 12× 12in (30 × 30cm)

Automatic Layouts

By far the simplest way to get started with a new book is to task Lightroom with laying it out for you. You can then tweak its work to meet your specific requirements by editing the pages one at a time.

The way that Lightroom positions your images in the book depends on the selected Auto Layout preset. As ever, you can create your own presets, but in the first instance Lightroom ships with three presets already in place:

1.

One photo per page, which zooms each image so that it fills the page as far as each border, cropping the shots as necessary.

2.

Left pages blank, with a single photo on each right-hand page, with the photos scaled to fit so that there is no cropping aside from the regular page bleed.

3.

Left pages blank, with one photo on every right-hand page, supported by a caption drawn from the image metadata.

Every time it places an image in your book, or you place an image manually at a later point, Lightroom overlays that photo's thumbnail in the Film Strip with a number that increases to show how many times it has been used in the current publication.

The numbers that appear above your image thumbnails in the Film Strip indicate how many times each one has been used in your book. The first image in this strip has been used twice— once on the cover and once inside the book.

If you've already selected an automatic layout and want to switch it for another preset, first click Clear Layout before selecting the new preset and clicking Auto Layout for a second time.

Defining Your Own Layout Presets

If none of the pre-defined presets meets your needs, you can define your own by choosing Edit Auto Layout Preset … from the preset selector drop-down menu. As its name suggests, this initially opens the currently-selected Preset for you to edit, so be careful not to over-write it directly once you've made your changes if you want to expand your choices, rather than swap out one for another. Do this by making your changes and then selecting Save Current Settings as New Preset … from the drop-down menu at the top of the dialogue box.

The preset editor lets you specify different layout styles for your left and right pages, with four options in each instance.

Blank, and Same as left / right speak for themselves, leaving the page in question blank, or using the same layout as the one that faces it (although not the same image). Naturally you can't choose for both the left and right pages to reflect the page opposite without actively defining the layout of at least one or the other, or Lightroom won't know what to copy in each instance.

"Fixed layout" lets you choose one of Lightroom's pre-defined page layouts so that you can predict with absolute certainty which will be used to position your pictures, while "Random From Favourites" gives Lightroom a certain degree of latitude.

When picking Random From Favorites you can go on to specify how many images should be displayed on the page, thus reducing the number of

"Favorite" layouts Lightroom can choose from, with options for layouts that accommodate one, two, three or four images. Ticking boxes beside more than one of these options increases the range of layouts from which it can make its random selection.

Either of these last two options— "Fixed layout" or "Random From Favorites"—lets you choose whether your images should be zoomed to fit or fill the cells in which they'll be placed. Images that "fit" won't be cropped, so you'll see the complete image, and if it's not the same ratio as the cell into which it's been placed you'll see blank areas on two sides either left and right or top and bottom—where it's been padded to fit. Images that are set to "fill" the cell will be zoomed so that there's no blank space on any side. In this instance, unless your image is the same size as the cell you'll lose a portion of the photo from either side or the top and bottom.

The Auto Layout Preset Editor lets you define the parameters within which Lightroom should work when positioning your images on the pages of a book under its own steam.

You can optionally add captions in Auto Layout, set them to align with your photos, and style them using text styling presets. We'll cover how captions and text styles work later in this chapter.

Before Lightroom can auto-fill your book using random Favorites, you need to tell it which layouts qualify as a Favorite. To save a preferred layout, select it in the Page panel in the Book module sidebar, right-click its icon and select Add Layout to Favorites.

Adding a layout to your list of favorites is a simple case of right-clicking it in the Page sidebar panel.

Changing Page Layouts

Just as you can change the size of your pages once they've already been laid out, you can also change their individual layouts as you progress, even if a page already contains one or more images and blocks of text.

Click a page in the main editing window and it takes on a thick yellow border, inside which you'll see a disclosure triangle. Clicking the triangle calls up the same list of layouts as you'll find in the Page panel; choosing one swaps it out for the current layout.

Clicking the disclosure triangle below a page lets you select an alternative layout, even if you have already placed content on the page.

Note that if you have multiple boxes on the page at the time you do this, and you select a single image layout, only the image on the left of the page will be retained. At this point you might want to swap out the image, in which case dragging a new image from the Film Strip replaces the one that appears on the page.

Lightroom automatically shuffles the images within your page layouts if you drag them around between the various picture cells, even if they didn't originally appear on the same page or spread. Dragging an image out of a picture cell into another picture cell elsewhere in your book that's already occupied by a different picture will replace the original occupant of that cell

and move it to the cell from which you dragged its replacement.

Naturally, if you drag an image from the Film Strip to a box that's already occupied, there's nowhere for the existing image to move to, so it's simply removed from your book and the number attached to its thumbnail in the Film Strip is reduced by one point.

Resizing Your Images

You can't specify the size of the cells in which your images sit on the page outside of selecting a whole new layout, but you can tweak the padding on each one to give the impression of different sizes, and you can increase or reduce the level the zoom applied to the images sitting inside each one.

Every time you click an image in your book you'll notice that a zoom slider appears in a bubble above the photo. Dragging this to the right enlarges the view of the photo within the frame, and if you drag it such that the image is larger than the cell on either the horizontal or vertical plain—or both—the cell boundaries will effectively crop off the over-matter. Right-clicking an image lets you task Lightroom with zooming it to exactly the right degree to fill the cell.

Zooming your images so that they fill the cell will often lead to some cropping, but it's nonetheless a neat way to produce a professional-looking finish.

Once you've zoomed an image to fill a cell, you might find that the way it has been cropped has led to a crucial part of the frame disappearing outside the cell boundary. You can retrieve it by repositioning the shot within the cell, by simply dragging it with your mouse. You'll find you can do this with a greater degree of accuracy if you view the page in isolation using the keyboard shortcut command-T on the Mac, and ctrl-T on the PC.

Dragging the slider to the left naturally reduces the size of the picture, but can lead to some awkward blank spaces on your page where Lightroom has to pad the cell if the image doesn't fill it in either direction.

While you can change the size of your image, though, you can't actually change the size or shape of the cell unless you choose a different page layout. What you can do, though, is change the amount of padding applied to the image within its cell. By increasing the padding you will effectively push the image away from the cell edges, introducing an empty white space that serves the same purpose as changing the cell size would.

Padding is handled by the sidebar's Cell panel. In its closed state it consists of a single slider that changes the level of padding on all sides equally, but clicking the disclosure triangle to expand it lets you uncheck the Link All box, at which point you can drag individual sliders—or enter values—for each side individually. Alternatively, clicking on an image border allows you to drag out an area of padding within the image cell.

Although you can't change the size of an image cell individually, you can adjust the amount of padding on one or more sides, which in turn moves the image away from the cell boundaries.

Book Module View Shortcuts

Command (Mac) or CTRL (PC) with E	View overview grid of all pages
Command (Mac) or CTRL (PC) with R	Show currently selected spread
Command (Mac) or CTRL (PC) with T	Show current page
Command (Mac) or CTRL (PC) with U	Zoom current page to 100 percent

A Helping Hand from Page Guides

Each page contains a series of guides, which help you to see how your photo will be treated when you send your book to be printed. They help to ensure that you won't have any nasty surprises, such as cropped text or a page with an unexpected white border where its contents don't quite fill the available space.

Each of the page guides is shown by default, and switching to single page view with command-T on the Mac or ctrl-T on the PC makes them easy to see.

The gray border that surrounds the page is the bleed area. You should make sure that any images you want to have running up to the very edge of the cropped page extend through this area to allow for slight misalignments in the trimming process. Any selected area within the page surrounded by a yellow box is the photo cell or caption box. This is effectively the window in which your photo or descriptive words can sit. Anything extending beyond the edge of a photo cell is cropped. Empty photo cells are shown as gray rectangles or squares with a "+" at the center.

A narrower gray border set inside the bleed border is the text safe area. You shouldn't allow any text to extend beyond this border or again you risk losing it in the trimming process, or having it difficult to read because it sits too close to the gutter at the center of the book where the left and right pages meet.

You can turn these guides on and off en masse using shift-command-G on the Mac and shift-control-G on the PC, and there are keyboard shortcuts for addressing them individually, which you'll find by clicking View | Guides.

GUIDE VIEW SHORTCUTS

The key combinations below toggle each described guide on and off with repeated presses.

Command (Mac) or CTRL (PC) with shift-J	Page bleed
Command (Mac) or CTRL (PC) with shift-U	Text safe area
Command (Mac) or CTRL (PC) with shift-K	Photo cells
Command (Mac) or CTRL (PC) with shift-H	Filler text

Managing Pages

Sometimes the proper flow of a book doesn't come to you until some way through the editing process. At times like that you'll need to rearrange your running order pages part way through the job, which is done quite simply by dragging the pages while hanging onto the fat border below each one—or each spread—in the multi-page view (press command-E (Mac) / control-E (PC) to return to this view).

As you drag a page or spread to a new position, the other pages around it shuffle to accommodate it, so dragging the left-hand side of a spread to the right will cause the page that was on the right to move to the left, and vice versa. If you need to make a more drastic move, you can break up spreads by dragging a page from one spread to the gutter between two others. In every instance, a yellow bar follows the moving page to show you where it will end up should you let go at any particular point.

As you add new images to your book, you'll need to add pages to accommodate them, which is done either through a right-click on a page and picking Add page or Add Blank Page from the context menu (the former of which adds a new page containing a blank layout matching the one on the page that you clicked), or choosing the same options from the Page panel in the sidebar.

If you do this through the sidebar and have a page already selected in the main editing window, then it makes no difference which layout is active in the Page panel as you'll always add an empty duplicate of the layout on the currently-selected page. You can change it once it's been created by picking a new one from the drop-down menu. If no page is selected, picking a new layout from the sidebar menu adds that layout to the book as a new last page, immediately before the closing flyleaf.

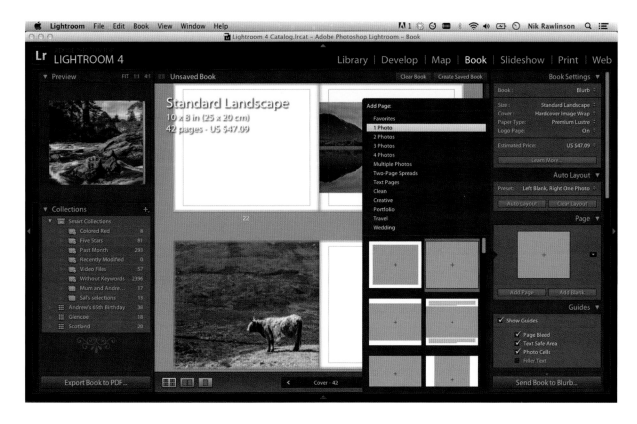

Adding a new page from the sidebar when there are no pages selected in the main editing window will add the page to the end of your book.

Remove pages you no longer need by right-clicking and selecting Remove Page from the context menu.

If you decide against including a particular page in your book, simply delete it by right-clicking and selecting Remove Page.

Adding Captions

If you've added titles or captions to your images' metadata, the Book module can use them to label your photos once they appear on the page. Precisely which metadata is displayed is up to you, with options for your times and captions supplemented by the image filename and a "custom" option that you can type directly onto the page. Each is selected through the sidebar's Caption panel.

In many instances, a custom caption will be the best option as it lets you describe your work specifically and in context, but bear in mind that anything you add here is only ever displayed on the page and isn't added to an image's metadata. That means it's specific to this instance of this particular book, and won't be visible in any other book or Web gallery.

You might choose to use the filename rather than a specific caption if you're creating a catalogue of photos for client approval, as it will allow them to choose a selection of shots for reprinting at a later point. In such an instance they would be able to supply you with the filename when they place their order.

The options for where to actually place the caption are limited, with the caption box only ever extending across the width of the image, even if you deselect the option to align it with the photo, and a choice of three positions that let you place it above, below or on top of the image. However, you can drag within the caption box to insert your text, and use the offset slider to position it higher or lower on the page.

The options for positioning your image are limited and reference the caption's relation to your image on the page.

On pages with two or more images that show different views of the same subject, it will often be more appropriate to use a single caption to describe all of the images at once. In this case, deselect the Photo Caption checkbox, and instead click Page Caption.

A page caption box extends across the whole width of the page, but can only appear at the top or bottom of the page. If you want it to appear between two stacked images that you have separated by increasing the padding between them, you can use the offset slider to move it higher or lower and thus reposition it on the page.

Modify Page:

- Favorites
- 1 Photo
- 2 Photos
- 3 Photos
- 4 Photos
- Multiple Photos
- Two-Page Spreads
- **Text Pages**
- Clean
- Creative
- Portfolio
- Travel
- Wedding

There's a small selection of text-only pages to choose from. These are useful for book introductions and travel journal pages.

WORKING WITH TEXT STYLE PRESETS

Lightroom ships with three text style presets for captions, and three matching presets for titles, which respectively cover serif, sans-serif and wedding styles. However, you can re-format your text in whichever way you choose, and save your settings as a new preset for future use on a caption-by-caption basis, on whole-page text boxes, or in the automatic layout tool, where it adds captions at the same time as placing your images on the page.

Text is controlled using the sliders and font-face drop-down menus in the sidebar's Type panel. Once you have defined the style you want to use, save it as a preset by selecting Save Current Settings as New Preset from the top-row drop-down menu.

You can define your own text styles to match a particular house convention, subject or client requirement and save it for future use.

Saving, Exporting and Printing your Book

As with any application and any body of work, you should ensure that you save your book at regular intervals throughout the creation process. If you don't, you risk losing it. To save your book for the first time, click the Create Saved Book button at the top of the workspace, give it a name and choose a location to store it.

When you've finished working on the book, save it again to ensure you have a safe copy of the most recent edition, and then decide how you want to handle the output. If you have chosen to publish it through Blurb, you'll see a Send Book to Blurb ... button at the foot of the right sidebar, which will upload it directly to Blurb's servers as soon as you enter your email address and password.

At the foot of the left-hand sidebar, meanwhile, you'll see a button that exports your book as a PDF, which is also present if you've chosen to create JPEG-based pages, in which case the Blurb button at the foot of the right sidebar will instead give you an option to Export book to JPEG ... Either option saves your book to a chosen folder on your Mac or PC, from which you can email it for approval, print it, or send it to a third-party print shop.

Chapter 6: Finishing Your Shots

Lightroom allows you to marshal an image from import to export, which means you don't need any other software to give most images everything they need. In this chapter, we'll look at the final yards of checking an image and sending it either to print, or simply exporting a finished file for upload to the Internet or a client. Lightroom's ability to work with different color spaces (see p.126)

has grown impressively over the years, and users of the newest versions—Lightroom 4 and up—will get the most benefit from the sections of this book on soft proofing. However, Lightroom's Print module is common to all versions of the software, and knowing how to use it will make a big difference whether you print yourself or use a professional outfit.

Key Points in this Chapter

This chapter will show you what happens once your images are processed, and are ready for uploading to the Internet, sending to a client, or printing either professionally or at home. We'll show you how to color-manage your images so you get the results you expect every time, as well as showing you how to create professional print layouts that will allow your fine-art prints to look their best wherever you hang them.

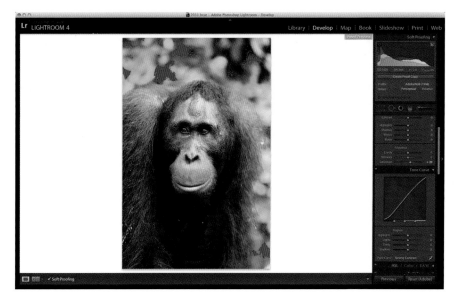

Soft-proofing helps you spot colors in images that are unlikely to be reproduced accurately.

How Lightroom Works with Color Spaces

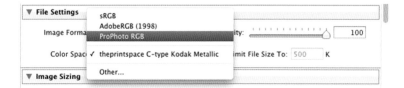

Understanding the need to use different color spaces is key to getting your photos to display reliably whatever they're being shown on.

Key to understanding Lightroom's soft proofing tools is a grasp of color spaces. A color space, simply, is a way of describing the number of colors a device can show. Your camera, for instance, works in either the sRGB or Adobe RGB color spaces. Of these, the sRGB color space contains fewer colors, so a photo contains fewer colors, so a photo taken in sRGB will potentially have different colors from one taken in Adobe RGB. Colors that are out-of-range will be approximated to the nearest shade the

color space has. For this reason, it's best to set your camera to shoot in Adobe RGB. To cover all eventualities, Lightroom uses the far larger ProPhoto RGB color space, which means it can render all the colors contained in a DSLR image and then some.

Different devices have different color gamuts, though. The exact colors a printer can produce on

paper depends not just on the printer at hand but on the type of paper being fed through it, so most high-end printers have color profiles available for them: small files which you import into an image editor so you can see what your image will look like when it's printed. Doing this allows you to spot out-of-range colors and make small edits so your image looks exactly like you expect it to.

Even if you're not printing your images, consideration of color spaces should still be in your mind. Many Internet browsers manage color poorly, and simply default to sRGB, so every image you export that's bound for the Web should be set to sRGB. You can do this in Lightroom's export dialogue (see p.131), but soft proofing your shot first should mean there are no surprises.

Introduction to Soft-Proofing

The first image is previewed in the sRGB color space, and the second in Adobe RGB, which is why the images have different amounts of red warning areas in soft-proof mode.

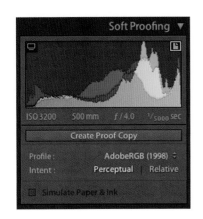

The highlighted paper icon at the top right indicates that Lightroom is previewing an image in soft-proof mode, and alerting us to out-of-gamut areas.

Soft-proofing is the practice of checking that the colors in your image will be reproduced identically on another device. Most Web browsers display images using the sRGB color space, so shots exported into the Adobe RGB color space might display with strange colors. Alternatively,

different combinations of printers and papers might not be able to reproduce all the colors in your original image. Soft-proofing allows you to display your image in different color spaces and using different device profiles to check that it will print properly.

To use it, switch to Lightroom's Develop module, tap S and the background behind your selected image will turn from gray to white, indicating that you're looking at a soft-proof. Next, click the drop-down box marked "Profile" and choose

sRGB. Next, on the histogram at the top right of the toolbar, click the small paper icon, and parts of your image will probably turn red, indicating the colors that the sRGB color space can't reach. If you display your image on an sRGB device without attending to the out-of-gamut areas, you can expect those red areas to change color slightly. The problem is that every device will treat the colors in your image slightly differently, leading to unpredictable displays of your carefully finished work.

What's the difference between hard- and soft-proofing? Soft-proofing is done on-screen, while hard-proofing is an actual print. Hard-proofing takes longer and costs more, but is more reliable.

Spend a small amount of money on a hardware calibrator and your display will be more accurate.

Loading New Device Profiles into Lightroom

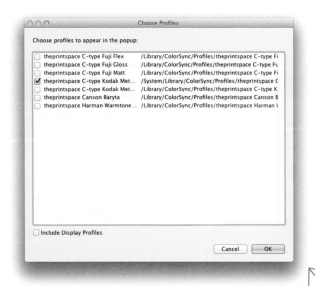

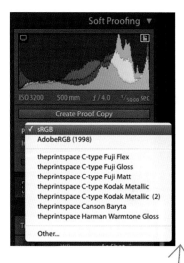

Downloading new device profiles and installing them on your system means you can use them in Lightroom.

Once profiles are enabled, you can use them for soft-proofing in the Profile drop-down box.

By default, Lightroom allows you to preview images in Adobe RGB and sRGB. Lightroom is very reliable when it comes to exporting images in either of these color spaces, so if you're processing shots for the Web, soft-proofing is optional—you can get away with simply choosing sRGB as the destination color space in Lightroom's export dialogue. However, when it comes to printing, every device is different, and soft-proofing becomes more important. Lightroom doesn't support any printers by default, so you need to import device profiles to preview your images. To do this, you first need to find a printer profile—high-end print shops will make these available for download, otherwise simply searching for the name of your printer and

the word "profile" online will often produce a good result. Printer profiles are more common for high-end printers, though. You'll also often find that professional photo printers give you the option of downloading profiles for different types of paper.

On Windows PCs, simply right-click a downloaded device profile and choose "Install Profile". On Macs, copy device profiles into your Library/ColorSync/Profiles folder. Restart Lightroom, and choose "Other" from the drop-down box under Profile in the soft-proofing toolbox, and you should find your new profile in the resulting window. It will now be available in the drop-down list, and you can start using it to soft-proof your shots.

Printers that use a CMYK process to produce color aren't supported in Lightroom.

Correcting Out-of-Range Colors

Being able to see which colors in your image are out of range is a helpful start, but correcting your shot for print is the next step. Exactly which colors are out of range depends on the device profile you're using, but for example, the sRGB color space is particularly limited when it comes to deeper shades of green. Fixing the colors in an image is all about reducing the red areas in the preview Lightroom shows.

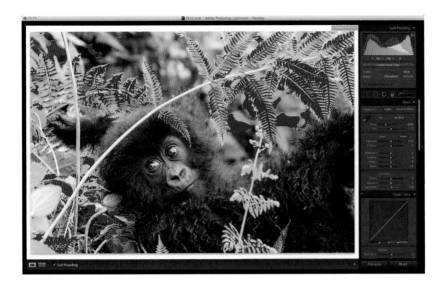

Step #1

In this image, with lots of deep greens, there are a lot of out-of-gamut areas, which means unpredictable results.

Step #2

The first time you make an edit in soft-proof mode, Lightroom will ask if you want to edit your original image, or create a virtual copy to use as a device-specific version. Creating a virtual copy is a good way of protecting your original, finished image.

Step #3

Out-of-gamut problems can often be fixed by adjusting saturation. However, instead of decreasing saturation in the image as a whole, Lightroom allows you to make edits to specific colors. To do this, scroll down the Develop module's toolbar to find the HSL/Color/B & W controls. You can alter the saturation of colors by name, but the best approach is to use the color picker, highlighted in red.

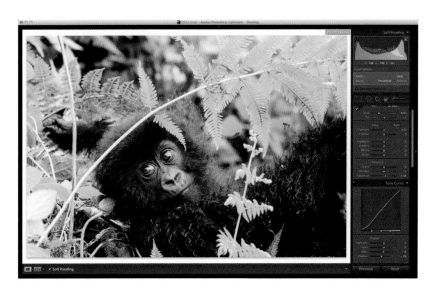

Step #4

Using the color picker, click an out-of-gamut area in your image, and drag the mouse towards you. The saturation in the area—and other areas of the frame with the same color—will be reduced, bringing their colors into the sRGB color space and removing the red warning tones.

When you're creating proofs of images for print, click "Simulate Paper & Ink," to see how how your image will look when it's printed on paper, which is a duller shade of white than your monitor. It also takes into account the fact that no printer ink produces "true" black.

Exporting Images

Lightroom doesn't edit your original image files, and that means that once you've finished editing a shot, adding keywords and generally making it ready for public consumption, you need to create a finished file that you can upload to the Internet or send to a client.

The Export dialogue box (File > Export, or CMD+SHIFT+E on Macs, or CTRL+SHIFT+E on PCs) gives you a wealth of options for creating a file. For example, if you're exporting multiple files, you can choose to give them sequential filenames, so if you were sending a batch of deer photos to a stock agency you can name them deer1.jpg, deer2.jpg and so on without having to manually rename your files. You can also opt to limit file sizes, which is useful if you're sending files to someone via email, or want people using mobile devices to see your images. For instance, if you're posting an image on Twitter, you might give Lightroom a maximum file size of around 400KB.

You can also specify the size, either in pixels, centimeters or inches, of your final image. This could be useful, for instance, if you're uploading to a site such as 500px.com, which shows images at a maximum of 900 pixels across—exporting a precisely sized image from Lightroom will save a little upload time.

Finally, those trying to maintain a little mystique about their images should note that the Export dialogue allows you to strip metadata from your image, hiding things such as the settings your camera used when you took the shot. Beware, though, that the top two options in the drop-down box under Metadata will remove your lovingly crafted captions and painstakingly listed keywords.

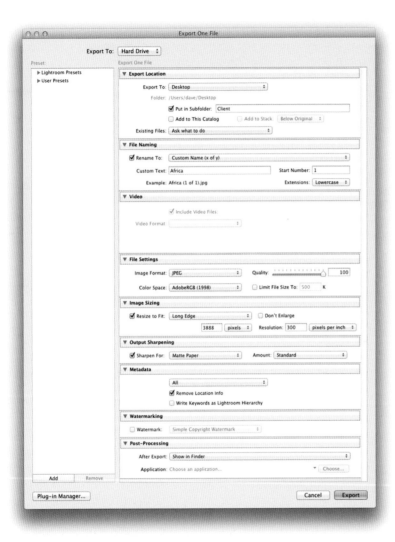

If Lightroom isn't the only application in your photography workflow, use the After Export: drop-down box to open your image in another editor automatically.

Introducing the Print Module

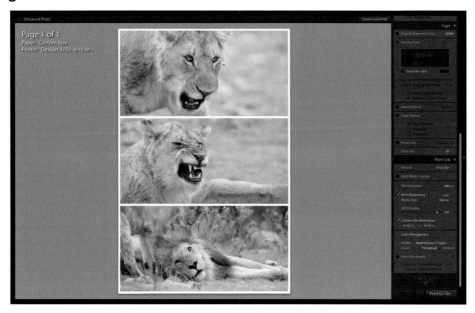

Creating triptychs like this is simple with the Print module, and you can easily create prints for your home printer, or print-ready files for professional print shops.

Printing in Lightroom involves a little more pomp and circumstance than simply hitting CTRL+P (CMD+P on a Mac) and having your printer whir out a finished sheet. Instead, the Print module (CTRL+ALT+6 or CMD+OPT+6 on a Mac) gives you a range of options so you can control how your image looks on the page. It's also good practice to use it to create JPEGs to send to professional printers, rather than simply relying on the Export dialogue. Not only does the Print module contain ways to create pages with multiple images on them, it gives you very precise control over aspects such as creating borders, as well as giving you fire-and-forget sharpening options for different types of paper. The big image preview in the middle gives you a large-scale preview of how your image will be laid out, giving you plenty of time to spot problems.

Custom, cell-based print layouts, watermarks and color-management options are all available from the Print module. If you create a cell that's a different shape from the original image, you can move the image around within the cell.

Creating Print Layouts

At its heart, the Print module in Lightroom is a miniature page-design application. The image preview goes from being merely a preview of your photo to being a preview of how your shot will be arranged on a sheet of paper. By default, it will use your default printer and your default paper size when laying your shots out, which in most cases will be A4 (UK) or Letter (US).

At the top of the right-hand toolbar are a few useful settings—the zoom option allows you to make sure your shots can be arranged full-bleed, allowing you to create borderless prints. It means that your shots might have small portions removed to fit the image onto your paper size. There's also a rotate option, which means the long edge of an image will always be aligned with the long edge of your photo paper, cutting down on the number of expensive outtakes your printer produces.

Below that is the Layout toolbox. It's here that you can create bespoke page layouts. The default approach to photo printing tends to be borderless, but as your shots get better and more worthy of a space on the wall, you'll want to start creating images with borders, either to add a little impact to your final print, or to accommodate the mattes that come with custom or pre-built frames.

Controlling page layouts with a single image on them is simple— the margins allow you to set the distance between the edge of the print and where the image starts, while the cell size is simply the maximum dimensions of the image. Often, you'll be creating images with, for example, a small border at the edges and the largest cell size available. However, if you're making a triptych, you might specify three rows under Page Grid, which will place three cells on the page. The images can be selected from the filmstrip (open it with F6), or if you've got images selected in the Library module, they will automatically be selected when you move to Print.

Rows run from left to right, and columns run vertically.

Ruler units can be set in inches, centimeters, millimeters, or points or picas, with spaces between cells, the edge of the page, and cell sizes themselves all adjustable to a hundredth of each unit.

To change the paper size in the preview window, simply click the Page Setup button at the bottom left of the Print module.

Printing from Within Lightroom

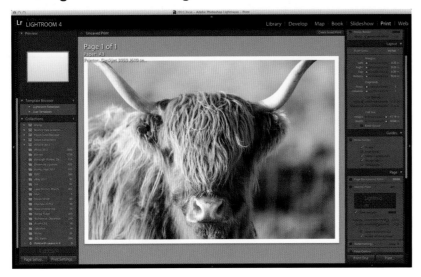

Finished print layouts can be printed from within Lightroom—a little care will avoid running off expensive prints with incorrect colors.

If you have a photo printer, you can print straight from Lightroom. And, as with soft-proofing (see p.125), you have the option of color-managing your files. If your printer came with a printer profile—or if one can be downloaded—you can have Lightroom manage color-matching by choosing your printer under "Profile."

You can also choose how Lightroom translates the colors in your original image to colors within the gamut of your printer when it allows you to choose the rendering intent immediately beneath the Profile box. Perceptual intent means Lightroom will bring out-of-gamut colors back in range, and will adjust other colors in the image to keep everything looking balanced. If there are a lot of out-of-gamut colors, this is the preferable option. Relative intent rendering means only out-of-gamut colors will be changed—useful if your image only has a few small areas with out-of-range colors.

Soft-proofing is an excellent way to protect yourself against running off unsatisfactory prints.

You can make a few last-minute edits to your shots in the Print module. You can opt to do another round of sharpening, with how Lightroom applies the effect dependent on whether you're printing on matt or glossy paper. You can also adjust brightness and contrast under Print Adjustment. These edits are harder to make than edits in the Develop module, as

none of them are made "live," instead being written to your file as it's sent from Lightroom to your printer. The benefit to using them is that these Print Adjustments are stored per printer profile rather than per photo, which means if you find your printer consistently generating dark prints, you can adjust brightness upwards, make another print and find the setting to use for all prints made using that particular printer. This fine-tuning takes quite a few prints, though—there's more accuracy and less trial-and-error on offer using soft-proofing.

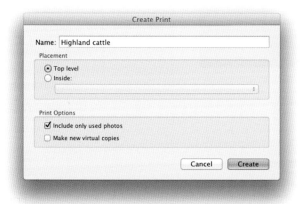

If you create a print layout with a specific shot that you're likely to print again and again, you can click "Create Saved Print" at the top of the preview window. This saved selection of images, as well as your layout, will appear at the bottom of the list of Collections in the left-hand toolbar.

Sending Images to Professional Printers

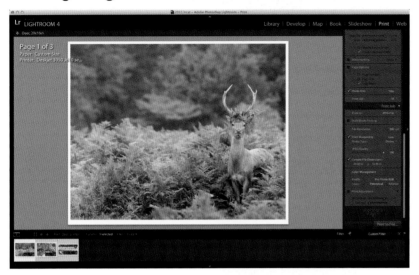

There are lots of advantages to using a professional printer—a far greater range of paper and finishing options for one thing, as well as a better selection of paper sizes. There are two ways to create a finished file to send to a printer. The most obvious way is to simply export your file using File > Export (see p.131). The benefit to doing this is that you can choose different file types, but producing a file for printing from the Print module offers a little more control.

For one thing, choosing "Print to: JPEG File" will keep elements such as borders, and allows you to create pages with multiple images without having to export files, then open them again in another editor such as Photoshop to create a new layout.

Creating multiple JPEGs ready for print is simple—use the Filmstrip (F6) to select all the images you want to print, then when you enter a filename after choosing "Print to File," each image will be saved with your chosen filename and a sequential number.

Like the standard Export dia-
logue, the Print module allows
you to create print-ready JPEGs
at specific sizes. For instance, if
you're running off a set of
holiday snaps intended for 6 ×
4 inch paper, you can simply
choose Custom File Dimensions
and enter the intended size of
your final print, and Lightroom
will create a file with the appro-
priate dimensions and resolu-
tion. This means if you're
uploading 100 postcard-size
shots to an online printer you
can work with smaller file sizes.
Alternatively, you can enter
bigger dimensions and generate
larger files.

Creating a file for
print, rather than
sending a file from
Lightroom to your
printer, is
controlled from
the final panel on
the Print toolbar.

Chapter 7: Slideshows and Web Use

Print is the most permanent way of showcasing your images, but modern photographers ignore the Internet at their peril. If your images capture the imagination of enough people, you could find your work making its way in front of millions.

Still, creating a custom website can be a drawn-out, expensive affair requiring a decent level of coding skill, and most people would rather be out photographing. To that end, Lightroom makes creating digital versions of your work easy. Of course, there's always the Export dialogue box (see p.131) for creating standalone JPEGs, but Lightroom's Slideshow and Web modules allow you to create neat, self-contained websites or slideshows that you can upload. The slideshows and Web pages you can produce can be customized, and there's a healthy online community creating add-on templates for Lightroom—a quick Google search can produce some surprisingly high-quality results, both paid-for and free.

> ### Key Points in this Chapter
>
> In this chapter, we'll look at what to do if you want to create galleries of your work that live online, rather than in print. We'll investigate what the Slideshow and Web modules do, and how to create bespoke versions of both. By the end of the chapter, you'll be able to create customized galleries for anyone with a computer, whether you're showing your pictures to a legion of online fans or sending off virtual contact sheets for clients.

The slideshow and website modules offer quick and easy ways to get your work online.

Introducing the Slideshow Module

Canon EOS-1D Mark III - EF70-200mm f/2.8L IS USM

The Slideshow module can be used to produce packages of your images that can be played back on a variety of devices.

The Slideshow module (CMD+OPT+5, or CTRL+ALT+5 on PCs) in Lightroom offers the most control over how people view your images, and gives people the widest variety of devices to view your images on. The Web module (see p.152) only supports Web browsers; the Slideshow module supports any device that can play video. So not only can you produce files for YouTube, for example, you can also create iPad or iPod-ready files for people to view on portable devices. You also get control over your slideshow timings—think of the Slideshow module as being a cut-back, photos-only version of Powerpoint. You can add various text overlays to add a little decoration or context to your shots or, for those looking for a little more wow-factor, you can add a soundtrack.

Selecting the images to use in a slideshow is simple—you can either choose them by selecting a Collection, or you can use the Develop module's grid view to CMD+click (CTRL+click on PCs)

a selection of different shots. Alternatively, once the Slideshow module has loaded, you can use the filmstrip at the bottom (F6 if it's not already visible) to choose the photos you want to use.

Virtually every aspect of a slideshow can be controlled, from the size of your images to their layout on the screen. Backgrounds and watermarks can also be adjusted and, usefully for those giving presentations about their photographs, various bits of EXIF data can be included to clue people in as to your camera settings as each image appears.

Once your slideshow is finished you have various options. If you're running a presentation from your own computer, you can simply click Play and Lightroom will render your images and start playing. However, for reaching people online, the ability to create videos in a variety of different formats straight from Lightroom proves its worth time and again.

Customizing a Slideshow

The template browser gives you a base to start your slideshow from.

The Overlays panel allows you to control the appearance of automatically-generated text.

The intro and outro screens of your slideshow can be customized, either with text, or you can create an image such as a logo to use as an identity plate.

The ABC logo allows you to add custom or predefined text overlays to a slideshow.

If you're on a multi-monitor computer, the Playback Screen allows you to choose which screen your slideshow will appear on when you hit Play.

The quick n' dirty way to create a slideshow in Lightroom is to use the Template Browser in the left-hand toolbar—press F7 if you can't see it already. The templates on offer feel a little like afterthoughts, though—there's only a handful and they can be a little basic, so it's best to treat each one as the starting point for a more interesting layout.

Of more interest are the powerful tools in the right-hand toolbar.

It's from here that you can choose how your photos will be laid out on the screen, for example, by moving the layout guides to determine how far your image's borders will be from the edge. Of more interest are the various text overlays you can use. These overlays can be generated automatically—you might have a text box on the screen which contains the IPTC title of your shot, for example, or another which pulls the name of the equipment you used from an image's EXIF data. To do this, click the ABC icon immediately below the slideshow preview window, and then either enter custom text into the wide text box, or click the drop-down box that says "Custom Text" and choose one of the automatic presets. You can even create your own automatic preset—click Edit … in the drop-down box and you can insert various chunks of text or data into a custom overlay. Once these overlays appear on your image, you can drag them to place them wherever you want, and you can click the anchors on the edges of the text frames to resize them.

You can add music from your computer to slideshows—choose Select Music from the Playback panel and navigate to any music file on your computer. We'd suggest subtle tracks are best, and make sure you've got permission to use the track from the copyright owner!

You can only use one audio track per slideshow—if you want to use more than one (for longer slideshows, for instance), you might need to blend different tracks together in an audio editor.

As with the Print module, you can save a slideshow once you've finished working on it. Use the small "Create Saved Slideshow" button at the top right of the main preview image.

Exporting a Slideshow

With your slideshow laid out how you want it, and your text overlays showing the right information in the right places, it's time to think about how you're going to share your work. If you're giving a presentation at a photography club, you might not need to actually export your slideshow—if your laptop or computer is hooked up to a projector, you can simply load Lightroom, navigate to the Slideshow module and click Play at the bottom right of the right-hand toolbar, and your slideshow will play back, full-screen. The benefit to using Lightroom to show a slideshow is that it's fast—rendering a finished video file can take a long time.

Canon EOS-1D Mark III - EF500mm f/4L IS USM

If you're running a presentation of your images from your own computer, Lightroom can run finished slideshows fullscreen at the click of a button.

Finished slideshows can be exported as video files for widespread viewing.

Remember—the Full HD files Lightroom generates will look great but have huge file sizes.

However, if you want to share your video online, or by burning it to a DVD for handing out, Lightroom allows you to export a finished version of a slideshow—simply hit "Export Video ..." in the left-hand toolbar and you're presented with a dialogue box allowing you to enter a filename and choose a video format. Which format you choose will depend on the devices you're expecting people to view your videos on—creating slideshows for mobile devices such as portable media players or mobile phones will allow you to use a smaller video resolution. However, for sharing online, using Full HD will make your video look its best. Using Full HD is also recommended if you've used a lot of text over-lays in your slideshow, as a higher resolution will leave that text more legible.

Finally, if you'd rather keep life simple, you can export your images as PDF files. These have certain drawbacks, not least the fact that your carefully timed transitions and soundtracks will be lost; if you've set your images to run in a random order you'll lose that too. The benefit, though, is a small file which can be played fullscreen by anyone with Adobe's popular Reader application.

Introducing the Web Module

The ability to quickly create a showcase of your images and get it in front of a magazine editor, client or picture agency is key to the workflow of professional photographers, and the more you photograph, the more you'll come to appreciate Lightroom's ability to knock out quick, lightweight image galleries from its Web module (CMD+OPT+7 or CTRL+ALT+7 on PCs). At its most basic, the Web module takes a selection of your finished images, applies the layout of your choice, then exports small, Web-friendly versions of your images and a small amount of HTML code. From there, you can send the folder Lightroom creates to your Web space, and anyone can either stumble across it or follow the link you send them. It's convenient and quick.

However, scratch the surface of the Web module and Lightroom is capable of much, much more than a dull, grid layout. Custom designs and different size images allow you to produce totally bespoke Web layouts. And, in the event that you can't find a layout you like—or don't want to get your hands dirty with Lightroom's layout options, there's a burgeoning community of developers creating astonishingly complex and graceful Web templates, varying from free templates created by enthusiasts to high-end professional websites that you need to pay to use. It's a good example of Lightroom's ability to cater for all levels of photographer.

The Web module can create smooth, professional-looking Web pages in the fraction of the time it would take you to code—or learn to code—one yourself.

The Adobe Lightroom Exchange, at www.adobe.com, has plenty of third-party Web templates.

Choosing a (Flashy) Web Template

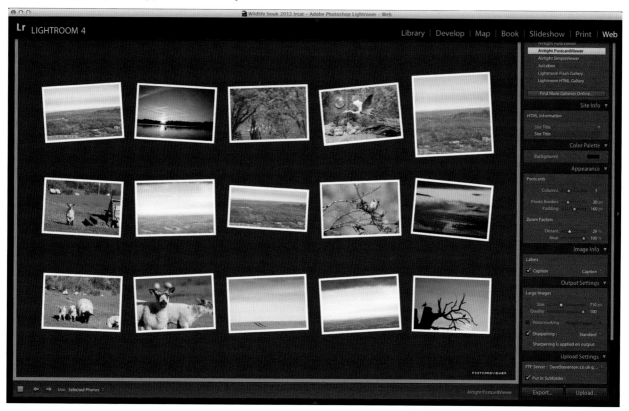

This glitzy Web gallery is coded using Flash. The procedure to create it is the same, but the number of portable devices it will work on is greatly reduced.

Downloading more Web templates from the Internet can increase your choices. For the best blend between functionality and compatibility with people's devices, look for either HTML or HTML5 templates.

If you're in a rush, Lightroom offers a set of dull-but-functional Web templates. These won't blow anyone away in themselves but, after all, Web slideshows are supposed to show your images off to their very best, and Lightroom's templates are at least undistracting.

One choice you need to make is the question of whether or not to use a Flash-based template. Flash is a proprietary Web standard that allows websites to run animations, and so Lightroom's Flash-based templates offer a little more glamor than their plain HTML counterparts. That means Flash galleries have attractive cross-fades between images, and more involving layouts, including side panels with image thumbnails that can be scrolled independently of the main image preview. However, Flash either runs poorly or not at all on many mobile devices—most notably, the Apple iPod and iPhone doesn't support it at all, so if you send someone the

address to a Flash gallery and they try to open it on a device that doesn't run Flash, your gallery simply won't work, which could be mightily embarrassing if you're sending a contact sheet to a client. If in doubt, it's best to use an HTML gallery. The result will look a little less impressive, but your images will take center-stage. Your website will load quickly, and it will load properly on virtually any device that can display Web pages. A bit of customization can put a more personal seal on a Web gallery, though—turn the page to see how.

Customizing a Web Gallery

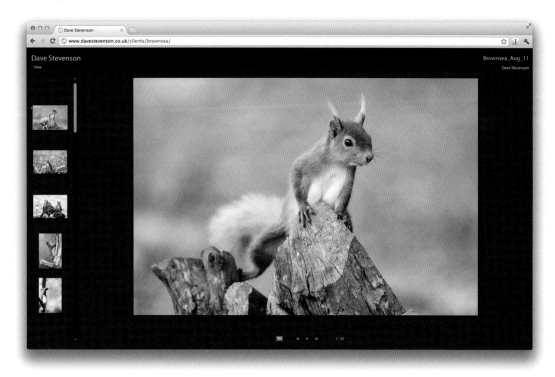

Even at their most basic, Lightroom's HTML galleries give you plenty of options to work with. The layout of its default templates offers less adjustability than its video slideshows (see earlier in the chapter)—you can't place text boxes on a page and drag them around and scale them to your heart's content, for example. Lightroom plays it cautious in terms of fonts as well—you can't change them at all.

However, there's plenty to get right all the same. It's worth remembering that the virtual contact sheets you create with Lightroom's Web galleries are going to be seen by the world at large, so your reputation is at stake at the very least—at worst you could end up uploading a lackluster Web gallery that hurts your reputation with potential clients.

The Site Info box hides some important things. The site title and so on will help people make sense of your site, but you need to make sure you leave the "mailto:" in the Web or Mail Link box, or the link won't load an email application when people click it. The Identity Plate works the same way as it does elsewhere in Lightroom—you can click the drop-down box and choose edit to enter your own text, or you can choose a graphic file if you've designed your own logo.

This panel controls the layout of your site. If you're going for a template that uses a grid, try to get as many images on the front page as will fit, rather than showing a small number of thumbnails and making people laboriously click through

endless grids. Showing cell numbers can be a good way of allowing your audience to tell you which images they liked—they can say "Image 12 was great," rather than "Do you remember that image with the man in it?" and so on. Finally,

the Image Pages option allows you to set how wide your images are in pixels. A bigger number is better here as your shots will look more impressive, but remember that some people will have monitors or devices with lower resolutions.

The final step in the toolbar before exporting your gallery is to choose what—if any—text you'll include. Often this will be the caption you've written—a bit of extra information for anyone looking at the image is always welcome. If your images don't have captions, you can have Lightroom display EXIF data from your image, such as the equipment used or simply the filename. Finally, the Output Settings tools allow you to choose what happens to your images as they're exported. The Quality slider works in the same way as the quality slider in the Export dialogue. If you know people will be looking at your site over fast broadband connections, leave this at 100 to stop your images suffering from compression artifacts. You can also choose to strip out metadata, preventing people seeing how your images were made. You've also got the option of applying a final round of sharpening, but as with sharpening in the Print module (see Chapter 6), this is a change made while the files are being exported, so it's best to try to get your images sharp in the Develop module, where you can see what you're doing.

Exporting a Web Gallery

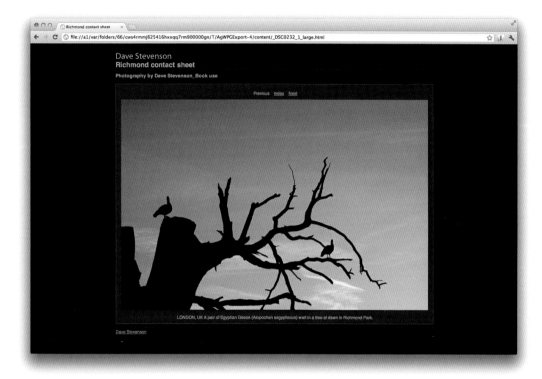

The URL at the top of this browser window shows that this website is being previewed locally—it works as it would if it were on the Internet, but so far nothing's been uploaded.

With your gallery finished, preview it before attempting to deliver a killer gallery to a magazine editor. This way, you'll spot images that aren't quite right, images that don't make the impact you'd hoped for, and it's almost inevitable that you'll find spelling mistakes. The "Preview in Browser" button is at the bottom of the left-hand toolbar.

When you're sure everything's as it should be, you have two options for uploading your site. The first is the Export button, which creates a local copy of your site in a folder on your computer. This folder will work perfectly if you open it in a Web browser, so this is a good way to share a set of images with a specific person. Alternatively, if you've got Web space available to you, you can upload the folder via an FTP application such as the (free) Filezilla.

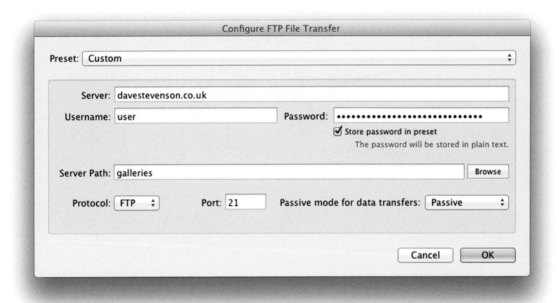

The easiest approach to uploading your site, though, is to use Lightroom's FTP capabilities. Next to "FTP Server" click the drop-down box and choose edit. Here, you can enter the address of your FTP server, your username and your password. You can also choose a folder that all your uploaded sites will live in under "Server Path". You can save this preset (and more

besides if you've got more than one FTP server) and simply choose it from the drop-down box the next time you've got a gallery to upload. Now, the only thing you need to do to get your gallery online is click Upload. If you opted to save your FTP password you won't have to do anything more—just wait for Lightroom to create your website and upload it.

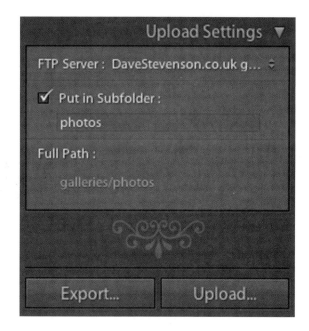

You can choose a custom folder name for your gallery in the Subfolder text box.

/

Chapter 8: Editing Movies

The modern photographer has to master a couple of trades. Still photography is the essential one, but with modern DSLRs shooting extremely high-quality, Full HD video, any photographer not routinely shooting video of their subject could be missing out on unique—and potentially lucrative—footage.

Lightroom has offered basic video support since version 3. You can see video files in the Library, and you can flag clips and apply metadata such as keywords. Lightroom 4, however, offers a far more complete set of tools. Not only will Lightroom recognize video files and allow you to tag them as part of your library, but you can also edit them. You can edit video clips for length, and you can apply edits such as exposure, saturation changes, and apply develop presets just as you would to a still image. Lightroom is no replacement for a full-blown non-linear editor such as Adobe Premiere or Apple's Final Cut Pro, but for occasional videographers, or those who want to do batch-editing on video files before loading them into another application, Lightroom, as ever, can offer significant time saving.

Key Points in this Chapter

In this chapter you'll find out about Lightroom's key video capabilities, and how dealing with video files is similar to working with stills. We'll investigate how to manage video metadata, and how to cut bits of video clips you'd rather lose. You'll also find out how to apply color correction and other edits to video files, and how to use develop presets to expand on Lightroom's default abilities. Lightroom 4 also offers vastly expanded video output options, so we'll look at how to export your videos and which settings to use.

Lightroom is no substitute for a high-end video editor, but can lay the groundwork and apply basic color fixes.

Working with Video in Library Mode

Importing video to Lightroom doesn't need a second thought, whether you're importing direct from a camera's memory card or from a folder already on your computer. The import dialogue simply pulls in video files along

with stills, and treats them exactly the same.

Indeed, Lightroom's behavior with video files is almost entirely consistent with stills. The edits you make—whether you're clipping files or editing them—are non-destructive, so, as with images, you're not actually making changes to the original files.

Because of the non-destructive approach, Lightroom allows you to do many of the same things to movie files as you can do to images. For example, pressing CMD+' (CTRL+' on PCs) creates a virtual copy of a movie, allowing you to create two differently-edited versions of the same file. Flagging, rejecting, rating and color-coding still works, allowing you to

sort your work just as efficiently as you handle your standard images. Other key data, such as keywords and other IPTC fields, can also be filled in as part of your standard workflow. We'll cover video export options on p.184, but it's worth noting that video files work with some publishing services as well, so you can automatically send clips to Facebook and Flickr along with stills.

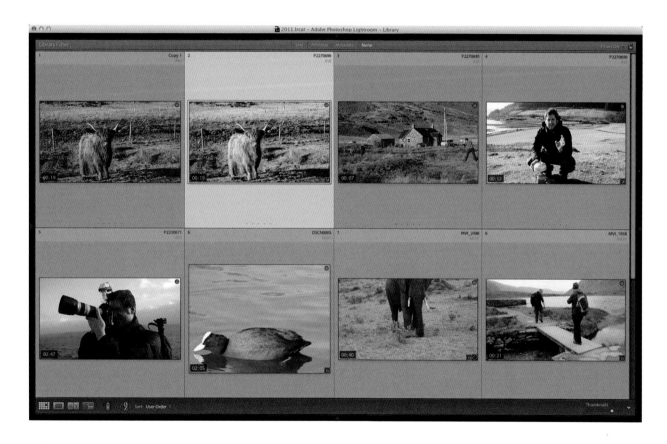

The video at the top left now exists in color and black and white—but there's still only one video file thanks to virtual copies.

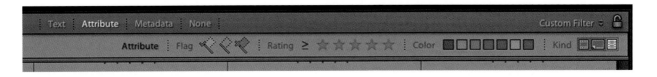

To only show video files in the Library module, click Attribute in the filter bar, then click the vertical filmstrip on the far right of the toolbar.

For an at-a-glance look at the contents of a video clip, simply move the mouse pointer from one side of its Library thumbnail to the other to scroll through the action.

Clipping Video

Lightroom has a few limitations when it comes to video—this isn't the application to use for creating a multi-layered, 30-minute documentary, not least because you can't create a new clip consisting of multiple clips woven together. There are no audio controls to speak of, and anyone hoping for the likes of cross-fade transitions will be left disappointed.

However, there are a few editing options that work well. For one thing, you can clean up video clips prior to importing them into "proper" video editors. Usefully, for instance, you can chop bits off the beginning and end of your video clips. This is useful— most video clips have a few seconds at the beginning and end while the photographer gets comfortable and shuffles the camera around, so these can be discarded—non-destructively, of course.

Step #1

As with many clips, this video starts rather inelegantly, so we're going to clear out the wobbly, loud bits at the beginning and end. Double-click the thumbnail of your video to show it full-screen, then click the cog icon to show a Film Strip—a horizontal set of thumbnails representing the progression of your video. The yellow marker can be clicked to any part of your video to jump you to different points. If you click and drag the marker through the timeline, your video will play back with sound.

Step #2

00:34

There are two ways to remove bits of your video. The first is to click the very far left and far right control bars and drag them inwards: any part of the video left outside the control bars will be excised when you export your clip. However, you can also edit your clip with shortcut keys, which is faster. To do this, drag the yellow caret to the point you want your video to start, and press SHIFT+I. This marks that exact point in your video as the in-point. This works for setting the out-point of your video, too: drag the caret to the point you want your video to end and press SHIFT+O.

Using Quick Develop on Video

Lightroom 4 is the first version of Lightroom that allows you to actually edit the colors in your videos—however, you can't do this in the Develop module. Try to load the Develop module and you'll simply be dismissed with an error message. For basic editing, the Quick Develop panel at the top of the right-hand toolbar in the Library module is (almost) as good as it gets. This offers a reasonable amount of control. For example, you can have Lightroom set white balance automatically, or, by clicking the black triangle to the right of the White Balance drop-down box, you can set it yourself, either in the thumbnail view, or you can press "E" to enter the loupe view for a better idea of what you're doing.

There are a handful of other options as well. Auto Tone offers a one-stop attempt at fixing brightness and saturation, while various tools for exposure and directional arrows for adjusting contrast and saturation are also on hand. As ever, the changes you make are applied in real time, and you can play your video through with your changes applied. Users of high-end DSLRs, such as those that record video in H.264 format at 1080p, might find that rendering video and playing it back in Lightroom is a stiff challenge for older computers.

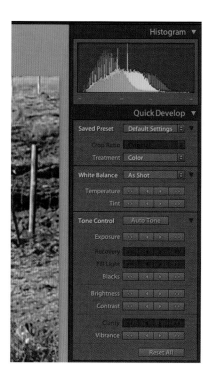

Creating Stills from Video

Modern DSLRs take amazingly detailed video, to the point that individual frames of video are more than good enough to be candidates for printing or publishing online. Since few cameras can shoot HD video and capture full-resolution stills at the same time, grabbing a frame of video and using it as a still image is a great alternative to missing out on crucial moments. Not only that, but capturing frames from video is an important part of skirting around Lightroom's restriction on what you can do when editing video. Here's how to splice out bits of video and use them as stills.

Step #1

This is the simple bit: simply find the part of your video that you want to save as a new image. It's worth hunting around a bit to make sure you're choosing a point in the video which is as sharp as possible—a challenge if your video has plenty of movement. To fine-tune your selection, you can use the arrow icons either side of the play button to move forward and backward a single frame at a time.

Step #2

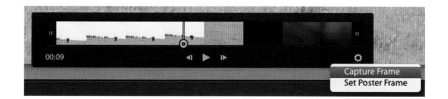

Once you've chosen the frame you want to grab, the small drop-down menu with the frame icon hides the Capture Frame option. It also hides the Set Poster Frame option—use this if you find that the default thumbnail for your video doesn't clue you in as to what the video is of. When you choose Capture Frame, Lightroom actually creates a brand new file on your hard disk, with the original name of your video clip, but with a .JPEG extension. If you create more than one new JPEG from the same clip, a dash and a sequential number is appended to the filename. The new file is immediately and automatically added to your Lightroom library, ready for editing or export.

Using Presets on Video

Some develop settings are not supported for video files. Only the following settings in the selected preset can be applied to video:

Auto Settings
White Balance
Basic Tone:
 Exposure, Contrast, Whites, Blacks
 Saturation, Vibrance
Tone Curve
Treatment (Color, Black & White)
Split Toning
Process Version
Calibration

☑ Don't show again OK

Not all the Develop settings in a preset can be used with video files.

If you've got this far and tried to edit your video clips in Lightroom, you could be forgiven for feeling a little frustrated. For all of Lightroom's prowess, the disabled Develop module for video files locks off important features such as the tone curve, lens calibration and the saturation slider. Some Lightroom options just can't be applied to video, such as sharpening or a vignette, but a workaround allows you to do more to your video files than the Quick Develop panel in the Library module allows you to.

To use it, first capture a frame of your video as on the previous page. Next, open it in the Develop module and apply the

settings you want. Typically video from DSLRs needs a little added punch in the form of either a tone curve adjustment or a simple pull on the saturation slider. Adjust the image until you're happy with how it looks, then save a new Develop preset using the addition symbol in the left-hand toolbar. Click "Check All" in the next screen and give your new preset a sensible name. If you'll be doing lots of video work it may

be worth creating a new folder of user presets specifically for video.

Next, return to the Library module and select your video clip—don't try to flick to it with the arrow keys in the Develop module as it won't open. In Library, the topmost option in the right-hand toolbar is Saved Preset—choose your new preset in the drop-down menu and your video will be treated to the same effect as the captured frame you just edited. It's a slightly clumsy workaround, and

it's easy to imagine a more refined workflow being introduced in the next version of Lightroom, but for now it remains a good way of applying an effect to multiple clips at once. If you're editing a single clip and don't plan to apply the same edit to other videos in the future, it's possible to simply create a still frame from your movie and, with both it and your video selected, apply edits to the still frame with Auto Sync turned on.

This video clip has been treated to a Develop preset that includes tone curve and saturation adjustments.

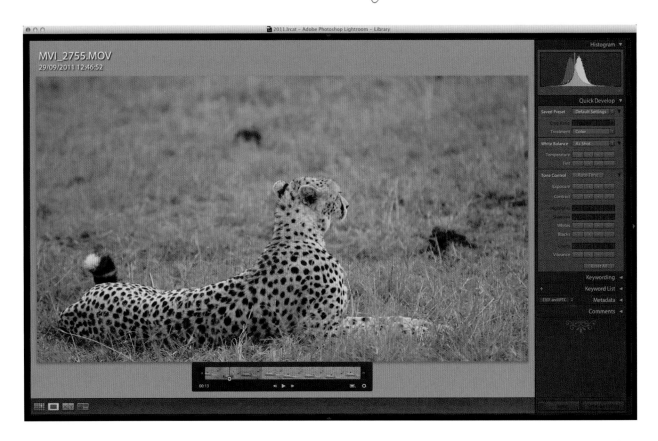

Before

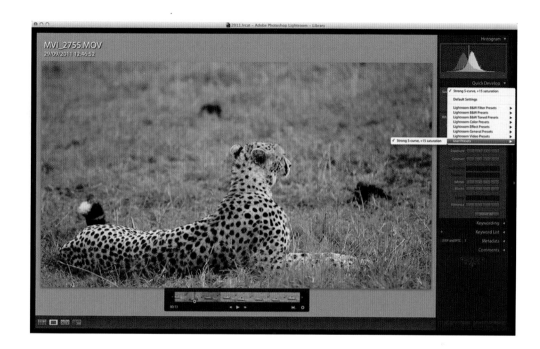

After

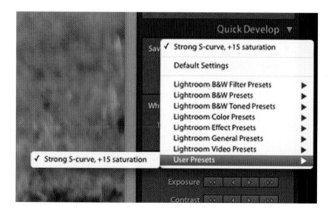

Publishing Video to Flickr

If all you want to do is share short video clips online to give your fans, friends and family an idea of what a shoot was like, Lightroom has a useful Publish tool to help get your work—stills and video—online with a minimum of fuss. The Publish Services panel is at the bottom of the left-hand toolbar in the Library module, and allows you to quickly send stills or video, at the resolution of your choice, to a variety of Web services. Out of the box, Lightroom can send video via the Publish Services tool to Flickr, but plugins for other services can be found online. The idea of the Publish Services tool is simple: authenticate your user details via Lightroom, and then drag finished files to the service of your choice. Your files are then automatically resized and sent on their way to your account.

To set up a Publish Service, click one of the grayed-out services in the Publish Service bar. Here we'll use Flickr—click Authorize under Flickr Account, which will launch your Web browser and allow you to authenticate Lightroom with Flickr. Follow the prompts and eventually you'll end up back at Lightroom, where you should click Done.

Step #1

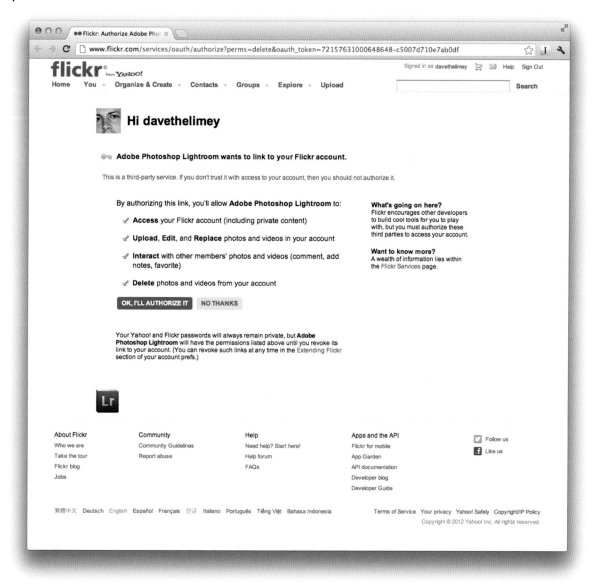

Step #2

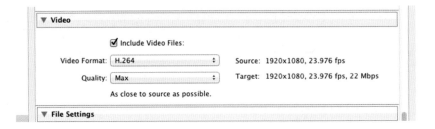

Since you'll be using this service for video, use the Video option in the Publishing Manager window to select how your videos should be treated. Flickr videos can't be longer than 90 seconds, and it's worth noting that if you upload an HD video to Flickr, it won't appear in HD to other people unless you have a Pro account. For a good balance between video quality and the time it takes to upload your files, the H.264 format at Medium quality setting will produce a video that looks good online without taking hours to upload.

Step #3

The final step is sending videos to Flickr. This is easy: simply find the video (and images!) that you want to share, and drag them onto the Flickr entry in the Publish Services sidebar. When you click Publish, at the bottom-right of the same toolbar, your files will be processed according to the settings you chose in Step 2, then uploaded. If you remove a file from the collection in Lightroom, it will be removed from Flickr as well.

Exporting Video

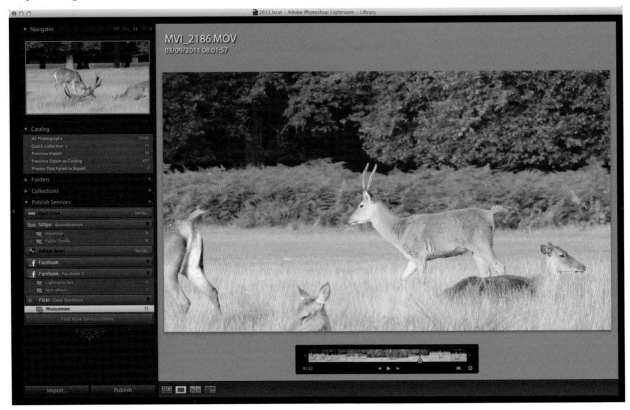

Because Lightroom treats video in the same non-destructive way it treats still image files, you need to export your clips if you've cut the beginnings or ends from them, or if you've made edits via a preset. If you've got Lightroom 3 you can still export video files, but only at their original resolution. In Lightroom 4, the video export options have been given a shot in the arm, and while you can still export in a file's original resolution, complete with all the changes you've made—useful if you're pre-editing in Lightroom before using a full-blown editor to finish things off—there are other options besides. Those creating high-end video can export in Adobe's DPX (Digital

Picture eXchange) format: this is an uncompressed, lossless format ideal for those who want to protect the quality of their file before they edit it. Alternatively, if your video is ready for sharing online as is, you've got the option of either 1080p or 720p, H.264-encoded HD video at various bitrates, or you can create lower-resolution files at 480 × 270. Usefully, video export is simply rolled into the standard export dialogue, so you can finish working on a set of images from a shoot and export all of your finished files all at once, regardless of what format they are. Exported video files obey the instructions you've set for filenames as well.

Lightroom can export video to Web-friendly formats, or high-quality professional formats for further editing.

Chapter 9: Anatomy of a Shoot

By the time you've made it this far through this book, you'll have a decent grip on how to use Lightroom to its best advantage. We've demonstrated how you can move large numbers of images around quickly, organize them in a way that makes tracking them down incredibly easy and, most importantly, create professional-quality images, along with all the EXIF and IPTC data that makes your work easy to find and, crucially, easy to work with if you start supplying your shots to a microstock or other photography agent.

The authors of this book practice what they preach, though, using Lightroom to supply finished images to a variety of agents for use in the media worldwide. This chapter is designed to show you a day in the life: the process of capturing a shoot and turning it into a finished package of professional, high-quality images ready for publication, without sacrificing quality at any point. Why the emphasis on speed? Simply put, the longer you spend editing your images, the less time you're in the field creating new work. That's the beauty of Lightroom: the speed of your workflow takes a shot in the arm, but the quality of your finished work is unchanged.

> ### Key Points in this Chapter
>
> You'll see how a photographer goes from capturing thousands of images on a shoot through to exporting those images, whether it's to a photo-sharing site such as 500px.com, or to the FTP server of a photographic agency.

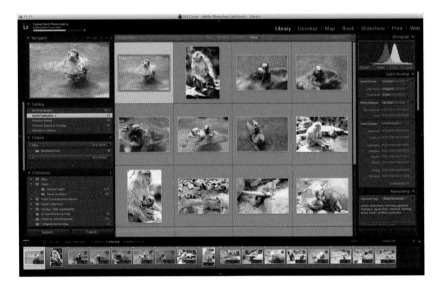

If your images are high-quality out of the camera, you can have them keyworded and exported to a professional standard in minutes.

Import (Or, How to Do Half the Work in a Single Step)

The name of the game here is efficiency, and with that in mind you want your images to be finished in as few mouse clicks as possible. To that end, remember that the Import dialogue does far more than simply copy images to your computer or import them into your library. The more you shoot, the more you'll learn the kinds of things you need to do to your images. Here, with a set of reportage travel and wildlife images shot in RAW, experience teaches us that a little extra saturation is often the only thing that needs to happen to a shot before it's ready. To that end, a preset that applies a contrast increase via the tone curve and boosts saturation has been prepared earlier, and the Develop Settings drop-down box will be used to give every imported image a little extra punch.

A little more backend work is done in the keyword box. Of course, not every image in a set will require the same keywords, but if all your shots are of the same thing—wildlife, in this case—or were shot in the same country, or involved travel, applying as many one-size-fits-all keywords as appropriate here will save a little time when it comes time to keyword shots individually. Finally, every image you add to Lightroom should have IPTC data added to it such as your name and contact details as you never know which images will become valuable later: applying IPTC data to everything will allow you to simply export images as they're needed. Here, a default metadata preset has been created containing the photographer's name, contact and copyright details: its selection in the Metadata drop-down box means every image in the set will have a consistent set of details attached. A little prep work before importing your files means everything in your library will be consistently keyworded and processed before you get your hands on it. If you've worked hard to get perfect pictures in your camera, this preparatory work should leave you with little to do.

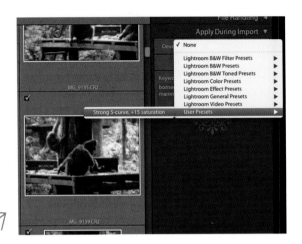

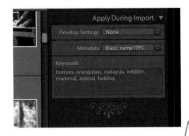

Using a Develop preset can all but finish most of your images.

Applying keywords to all of the images you're importing will save time later.

Picking and Rejecting Images

Of course, even with your best efforts, you'll end up importing images that will never be suitable for publication or distribution. When it comes to wildlife photography, failure to capture fast-moving subjects or autofocus "misses" are the major causes of rejections. The fastest way to pick and reject images is to press "E" to enter the full-screen loupe view, and use the "P" and "X" shortcut keys to add a flag or reject an image respectively. If you enable caps-lock Lightroom will automatically move to the next image once you've flagged or rejected it.

Generally, the flagging used at this stage is to distinguish images that might be usable from images that definitely won't be. Applying star ratings is a very useful way to set your very best work apart from merely functional photographs, but it's best to wait until you've finished processing images to choose "hero" shots to share online or send to clients—you never know which initially dismissed images might end up looking terrific with just a minor crop. A word of workflow advice: don't be afraid to reject technically perfect shots if they're near duplicates of other images. DSLRs with fast burst modes are a double-edged

sword, and mean you'll often end up with lots of very similar shots. Don't be afraid to pick your favorite and reject the rest. Once you've made your rejections, hit

CMD+BACKSPACE (CTRL+BACKSPACE on Windows PCs) to delete your chopped images from your hard disk. This final step is important the more

you shoot—you don't need hundreds of useless images clogging up your hard disk.

Using flags allows you to very quickly strip your imported images back to those with potential, and those which are wasting disk space.

Correcting Time Mistakes

Of all the in-camera mistakes to make, one of the most aggravating is the cardinal sin of forgetting to set your camera's clock when you arrive in a new timezone. This has lasting repercussions: getting the time right on your images is the mark of a pro, and image agencies will demand accurate timekeeping. Moreover, if your camera's time is off by enough you can end up with images with entirely the wrong date on them. Just as bad is having two cameras and

remembering to set the date on only one of them.

The best way to avoid this kind of problem is by putting a sticky note on every camera you take with a small clock drawn on it, which should encourage you to set the time correctly the first time you pull your kit from its bag. However, inevitably you'll still forget, so part of your workflow should be making sure the EXIF data your camera has appended to each image is correct. The time and date of each image you take lives in the right hand toolbar, and—thankfully—can be easily corrected by the forgetful.

To do this, select every image with an incorrect time (normally this will be all of the images you've just imported, so use CMD+A or CTRL+A on a PC to select every image in the current view). Next, click Metadata, then Edit Capture Time. You can change the time of each image to a specific date and time if you want, but the most straightforward approach is to shift the timezone. Remember that timezones to the east of your location are ahead of your time: New York is +3 hours to Los Angeles, for example.

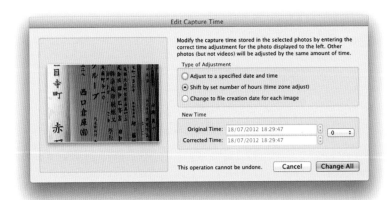

Best practice is getting the time right in-camera, but trips that include travel to more than one timezone are always tricky...

Applying a Correction to a Series of Images

If you used a develop preset when you imported your images, the amount of work you have left to do is limited: some images will take a bit of cropping, most will benefit from a tug on the sharpening slider, and Lightroom's chromatic aberration tool's effectiveness has to be seen to be believed.

However, if you've got an eye on the clock, Lightroom's ability to apply the same edit to a series of files should have pride of place in any professional or semi-professional workflow. For example, if you're using your camera on its manual mode, some shoots will contain at least a few shots that are over- or under-exposed. Normally a bit of precision chimping at your camera's histogram will allow you to correct the problem in the field, but if you've just shot a dozen frames in a high-speed burst mode you might find that you've got a perfectly-serviceable sequence of interesting shots that simply need some of the brightness taken out of them. Moreover, if you've shot in manual mode, every image in the sequence will be incorrectly exposed the same amount.

Fixing exposure can be done with the Quick Develop tools in the Library module, but it's best to be precise, so load the Develop module so you can view a single image at a time. Use the filmstrip (F6) to select each image you want to change, and click the auto-sync slider into the up position. Every change you make in the Develop toolbar will apply to every image, so in this case as you adjust exposure in one image, the same correction will be made in every other image you've chosen.

Lightroom has two presets for sharpening. One (Faces) is tuned for low-frequency images—that is, shots without lots of hard edges, while the other (Scenic) is tuned for high-frequency shots such as landscapes.

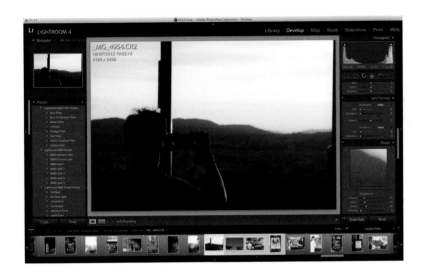
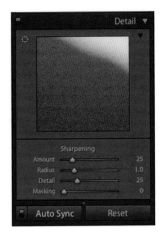

Here, a series of four images taken with the same lens have been selected. Flicking the Auto Sync radio button up means sharpening applied to the first image in the series will happen to the rest in equal measure.

Quick and Dirty Slideshows

The next step is creating a quick slideshow for client approval. This is an important step—exporting full-size images and uploading them to an FTP server takes a long time, so it's better to have a fast, lightweight gallery to gather first impressions. While there's a lot to be said for having a nice, consumer-friendly website, what

art editors and picture desks really want to see is an at-a-glance selection of your best shots to help them decide whether the picture package you've developed is for them, before you invest the time in uploading bigger images.

Happily, sending a fully-working gallery of images to a Web server is a snap—if you've got adequate space on your domain you can create a new slideshow for each shoot you do. As ever, the name of

the game is speed, and with your picks and rejections flagged appropriately, all you need to do is head to the Web module (see p.152 for more detail), and choose "Flagged Photos" from the drop-down box at the bottom of the screen. Make sure your email address is correct so those who arrive at your gallery by chance can get in touch, and use an FTP preset with your details pre-saved so all you need to do is click Upload.

You can change the order of the images in a Web slideshow while you're still in the grid view in the Library module. Common sense dictates you put your very best images at the front of the gallery to make the biggest impact on potential clients.

Resist Lightroom's glamorous, Flash-based Web slideshows—the last thing you need is a client to be unable to see your work on a mobile device.

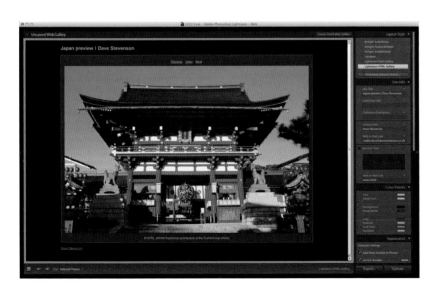

Images in Web slideshows should be big—assume your clients have a decent Web connection and go for image quality over small file size.

Installing an FTP Client

The default workflow for uploading files to a client is to export your images to your desktop, then open a third-party FTP client to send your images to a server. We recommend the freeware Filezilla, available from www.filezilla-project.org.

However, while it's far from obvious, you can upgrade Lightroom in a few simple mouse clicks to include a basic-but-functional FTP client.

The first thing you need is the Lightroom Software Developers Kit, a set of tools designed to allow programmers to develop plugins for Lightroom. Find it at http://www.adobe.com/devnet/photoshoplightroom.html, download it and unzip it. Then follow the steps below to install the FTP plugin to be able to upload finished images to an FTP server of your choice—without opening another application.

Step #1

Move the ftp_upload.lrdevplugin folder somewhere logical that it won't get accidentally deleted. The folder Lightroom is installed in is a good bet, as is your photos folder.

Step #2

In Lightroom, click File, then Plug-in Manager. This brings up a list of all the plugins currently running in Lightroom. The more plugins you use—such as tools to upload to popular photo-sharing sites such as 500px, for example—the more useful the Plug-in Manager becomes for trouble-shooting stability and performance issues.

Step #3

Click Add in the bottom left of the Plug-in Manager, and in the resulting window, navigate to the folder you've stored the plugin from step 1 in. Click Add Plug-in and the FTP tool will be installed and activated.

Step #4

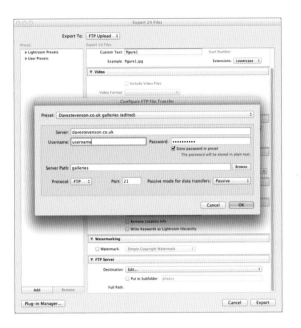

Go to Export (CMD+SHIFT+E on Macs, CTRL+SHIFT+E on PCs). Under Export To: at the top, the dropdown menu now contains an option called FTP Upload. The dialogue is standard, with options for image size, quality, sharpening and so on, but at the bottom is the option of uploading to an FTP server. You can't simply pop in an address, username and password, but any FTP server you've already saved from the Web module will appear in the drop-down menu. The one thing you can do is have Lightroom create a new directory on your webspace, so you can create URLs such as www.davestevenson .co.uk/galleries/monkeys, for instance.

Index

Page numbers in **bold** refer to illustrations.